Dear Lisa,

I never thought in all my days, my sister would ever be an art lover!

But since you are enjoy the Best!

Love
Forever
Greg.

MONET

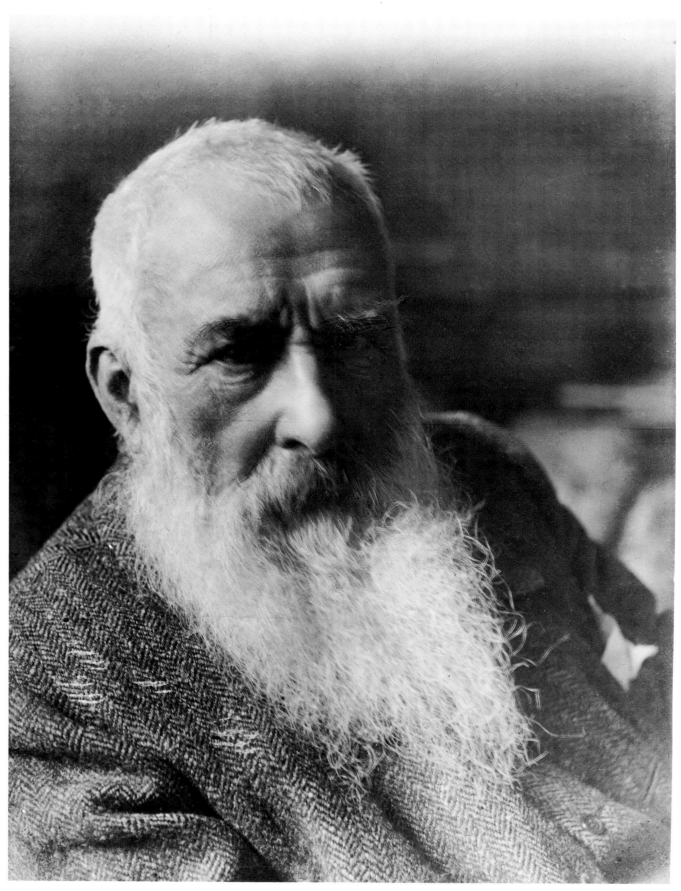

Monet, about 1926 *(Photo Viollet)*

CLAUDE
MONET

WILLIAM C. SEITZ

HARRY N. ABRAMS, INC., PUBLISHERS, NEW YORK

Library of Congress Cataloging in Publication Data

Monet, Claude, 1840–1926.
 Claude Monet.

 Concise edition of the author's Monet originally
published: New York: Abrams, 1960.
 1. Monet, Claude, 1840–1926. I. Seitz, William
Chapin. II. Title
ND553.M7A4 1982 759.4 82-8883
ISBN 0-8109-5328-5 (EP)
ISBN 0-8109-1341-0 (HNA)

Picture reproduction rights reserved by
S.P.A.D.E.M., Paris

Printed in Japan

CONTENTS

Claude Monet *by William C. Seitz* 9

COLORPLATES

ACKNOWLEDGMENTS

It was the support of the Department of Art and Archaeology of Princeton University that enabled me to pursue my study of Monet. Subsequent travel, research, and photography were made possible by both the University and a grant from the United States Government under the Fulbright Act. To recognize this aid, and the enlightened programs that offered it, gives me the greatest pleasure.

Any systematic study of Monet's work must be based on the *catalogue raisonné* by Daniel Wildenstein, which is now in preparation. I am grateful to Mr. Wildenstein for his courtesy in having placed at my disposal his documentation and photographs, some of which have been used in this book, and to his associates in New York and Paris for their generous assistance. Charles Durand-Ruel allowed me unqualified access to the famous archive of the Durand-Ruel Gallery in Paris, and responded to countless requests for information and photographs with a friendliness and interest shared by the members of his staff. At the Louvre, Mme. Hélène Adhémar, of the Department of Documentation, opened the valuable materials in the Monet dossier to me, and Albert Châtelet made it possible for me to examine paintings not otherwise available. In New York important cooperation was given by Edouard Morot-Sir and Mme. Anne Minor, both of the Cultural Division of the French Embassy.

I also wish to express my gratitude to M. and Mme. Michel Monet, who permitted me to study works in their collection, authorized me to reproduce unpublished early drawings, and extended warm hospitality. Jean Gimpel permitted me to quote from unpublished interviews with Monet recorded in the diary of his father, René Gimpel. Other firsthand accounts and documents were made available to me by Jean-Pierre Hoschedé, Mme. J. Cachin-Signac, Mme. Henri Focillon, Mme. Katia Granoff, Mme. Ernest Rouart, Mme. Germaine Salerou, André Barbier, Raymond Lindon, and Ernest L Tross. Emile Vinchon, Michelangelo Muraro, and Gaston Thiery assisted me in locating certain of Monet's painting sites.

It would be impossible to list all the museum directors and curators, scholars, collectors, and dealers who have given me information and assistance, provided me with photographs, or allowed me to study paintings in their collections or under their care; it must suffice to acknowledge the cooperation of Miss Waltraut van der Rohe, Ronald Alley, Alfred H. Barr, Jr., Henry Clifford, William Constable, Richard S. Davis, Perry T. Rathbone, John Rewald, Daniel Catton Rich, Helmut Ripperger, Gabriel White, and Harris Whittemore, Jr.

Finally, I should like to thank Miss Rosalie Green, who read the manuscript; Irene Gordon for her scrupulous and scholarly editing; and Irma S. Seitz for constant and immeasurable help.

WILLIAM C. SEITZ

Claude Monet

THE HOME of Claude Monet, with its adjoining studios and gardens, has finally been classified by the French Government as a national monument. It lies in Giverny, some fifty miles from Paris, where Monet was born in 1840, and about ninety from Le Havre, where he spent his childhood. Giverny has the atmosphere of a bucolic suburb rather than a village. Except for an inn, a shop or two, and the church (in the yard of which Monet's tomb occupies a place of honor), it consists of a main thoroughfare—Rue Claude Monet—lined with pleasant villas. This road separates from the old Chemin du Roy at one end of the village and rejoins it at the other. Monet's remodeled farmhouse occupies a walled enclosure between the two, but it is the rear of his house that faces the street bearing his name, for this street did not exist when he moved to Giverny in 1883. In summer, through the iron fence and the central gate on the Chemin du Roy, a passer-by can still see the garden and the central pathway that leads to the long porch. Two studios flank the house; in the one at the right, with an immense skylight, Monet painted the celebrated water landscapes which, after his death, were installed in two oval rooms in the Orangerie of the Tuileries Gardens.

Monet once jokingly remarked that he had a railroad in his garden, for across the Chemin du Roy, up four steps, and over the tracks that connect Gisors with Vernon lies the entrance to the famous water garden. Beyond the rose-covered fence one can see poplars and weeping willows, and through the gate, the pond with its Japanese footbridge, a little forest of bamboo, and, on the water, clumps of floating water lilies.

Giverny today is as tranquil as the fields that surround it—but such was not always the case. A bare four years after the great Impressionist first occupied his rented farmhouse, young painters—the American Theodore Robinson among the earliest—began to be attracted by his presence. Sleeping chambers were added

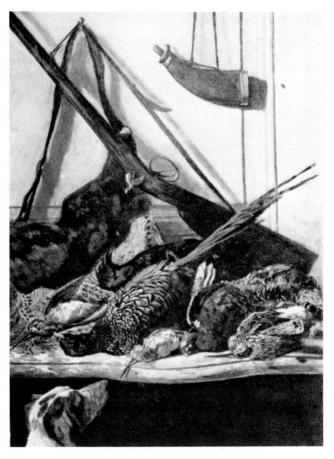

1. TROPHIES OF THE CHASE. 1862
Oil on canvas, 41 × 29 1/2″. *The Louvre, Paris*

2. MARIO OCHARD. About 1856. Pencil, 12⅝ × 9¾″
The Art Institute of Chicago
(The Mr. and Mrs. Carter H. Harrison Collection)

to the local grocery store. A few years later the American sculptor Frederick MacMonnies settled in Giverny, and as more and more converts arrived, the nights began to echo with artists' revelry. One of Monet's step-daughters, Suzanne, was courted by another American painter, Theodore Butler, whom she married in 1892. Gradually the quiet hamlet became a colony, and a fashionable society grew up, within which only English was spoken. About 1905 a certain Miss Wheeler opened a summer art class in which young ladies could learn the current Impressionist mode in the same fields sanctified by its master. But as the crowd gathered, Monet retired behind his garden walls, to see no one but special visitors, among them Auguste Rodin, Gustave Geffroy, Octave Mirbeau, and the "Tiger of France," Clemenceau.

During these later years, Monet was the most honored among French painters; but after his death in 1926, when academic Impressionism (which he de-spised) had fallen into disfavor, his pre-eminence was immediately questioned. The next year a debunking book by François Fosca (a pseudonym used by Georges de Traz) predicted that he would be remembered "as a liberator, rather than as a great artist." In the commotion made by more advanced modern styles, Monet was all but ignored. His unique achievements were obscured by criticism that viewed Impressionism as an outmoded group doctrine, or explained it by over-simplified generalizations. Indeed, Monet's reputation seems to have fluctuated along with that of Impressionism in general, and during the thirties and forties the direction was usually downward, for historical accounts were so often couched negatively: the achievements of Renoir, Cézanne, Van Gogh, Seurat, and Gauguin were alleged to have hinged on their rejection of the "formlessness" of Impressionism. But seldom, during these years, was the obverse of the same coin pointed out: that each of the Post-Impressionists had his origin in Impressionism; that (with, perhaps, the exception of Gauguin) they remained, in part, Impressionists all their lives; that what they had in common was, more than any other one thing, the example of Monet; that (in the words of Félix Fénéon, written in 1888) "the word 'impressionist' was created for him, and it fits him better than it does anyone else."

"Born of the sea," begins a historical account of Le Havre, the city where Monet spent his childhood, "the entire city lives by the sea and for the sea." In spirit Monet was a Norman. No other component of his artistic personality deserves more attention than does his early experience along the Channel and the Seine estuary. In fresh youthful paintings of the shore, of the harbors of Le Havre and Honfleur, and of small sailing craft bending before the wind or heading into the sunrise (figures 4, 5), Monet left a magnificent record of the scenes he loved. In Normandy—where during one moment the expanse of sky can contain both sun and storm—he learned to know the most fugitive and powerful of nature's forces and gained a fisherman's sensitivity to the weather.

Monet's father and uncles were wholesale grocers and ship chandlers. Something of their comfortable way of life can be discerned from the *Terrace at the Seaside* (page 53), in which the elder Monet sits gazing seaward, stolidly planted in his rustic chair. Except for Monet's aunt, who was an amateur painter, this family

circle disdained the arts, and it was mainly within this circle that Monet gained his early education. At school, where he hated to remain "even for four hours a day," he learned little, for he passed the time caricaturing his teachers on the pages of his copy books "in the most irreverent fashion." Whenever it was possible, he fled his "prison" to find freedom along the cliffs, beaches, and jetties, or on the water: "I should like to be always near it or on it," Monet later said of the sea, "and when I die, to be buried in a buoy."

Most of the traits that were to make Monet a great painter were manifested early. Like his tough-minded friends Zola and Clemenceau, he was not religious—indeed, he had little faith in anything that was not drawn from direct experience. He was persistent, had small need for social approval, and was stimulated by both hostility and adversity: "Without my dear Monet, who gave courage to all of us," Renoir once recalled, "we would have given up!" But not all his traits were

4. LE HAVRE: FISHING BOATS LEAVING THE HARBOR. About 1865. Oil on canvas, 37^1/$_2$ × 50^1/$_2$". *Hill-Stead Museum, Farmington, Connecticut*

5. THE MOUTH OF THE SEINE, HONFLEUR. 1865
Oil on canvas, 35^1/$_2$ × 59". *Private collection, Paris*

3. LEON MACHON, NOTARY. About 1856
Charcoal heightened with white chalk, 24 × 17^7/$_8$"
The Art Institute of Chicago
(The Mr. and Mrs. Carter H. Harrison Collection)

equally admirable, and some were quite in keeping with the Havrais circle that he professed to disdain. Though willing to endure any degree of discomfort for his art, Monet was never to lose a taste for the overindulgent pattern of French middle-class life. He ate, it is said, like four men; he could be taciturn and snappish, had a tendency toward vindictiveness, and exhibited a shameless craftiness where money and the sale of pictures were concerned. By the time he was sixteen he showed unmistakable talent, but he turned it to making caricature portraits at twenty francs a sitting.

It was Louis Eugène Boudin who, about 1856, in-

duced Monet to paint the coastal scenes that he already knew so intimately. Boudin was a sailor's son from Honfleur who understood the sea and shore at least as well as Monet. While operating a stationery and picture-framing shop in Le Havre he had been encouraged to study painting by his customers Couture, Millet, and the landscapist Troyon (who was also to play a role in Monet's career). Undistinguished as an art student in Paris, Boudin returned to Le Havre stubbornly set on completing his canvases out-of-doors.

Although outdoor oil painting is an accepted practice today, it should not be forgotten that it originated late in the history of art, and was not fully practical until after the introduction of metal-tubed pigment in the 1840s. John Constable made vital, even impressionistic, outdoor sketches in oil before 1810; but these, like watercolor sketches previously, were preparatory studies for more ambitious studio compositions. Corot, the Barbizon painters, and Courbet also made oil studies (or began large landscapes) in the open, but only

Daubigny ever finished pictures on the spot. Late in the fifties, it should further be noted, the Florentine group known as the Macchiaioli were, like Boudin, producing small outdoor figure paintings.

The precepts imparted by Boudin to his precocious student were unquestionably those that he recorded in his own notebooks. Self-depreciatory in tone, they are nevertheless rich, clearly expressed, and revolutionary. "All Monet's future," writes Monet's biographer Marthe de Fels, "is already in these timid notebooks of Boudin." Only a careful study can reveal their commitment and almost pantheistic devotion to nature. Tormented by a sense of his own incapacity, Boudin pursued a "perfection" of fleeting color and light that always eluded his technical grasp. He felt it was essential to retain "one's first impression," and discovered that "everything that is painted directly and on the spot always has a force, a power, a vivacity of touch that cannot be re-created in the studio." Quite simply, Boudin put forward Impressionism's cardinal principle, thus

6. LE DEJEUNER SUR L'HERBE (THE PICNIC). 1866. Oil on canvas, 48³/₄ × 71¹/₄″. *Pushkin Museum, Moscow*

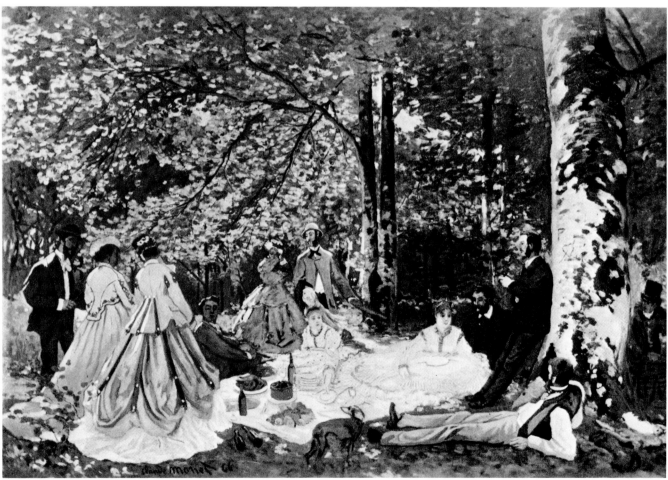

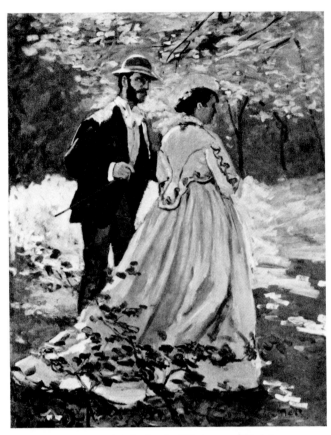

7. LES PROMENEURS (study for *Le Déjeuner sur l'Herbe*)
About 1865. Oil on canvas, 37 × 27″. *National Gallery of Art,
Washington, D.C. (Ailsa Mellon Bruce Collection)*

attentively, Monet watched: "Suddenly a veil was torn away. I had understood—I had realized what painting could be. By the single example of this painter devoted to his art with such independence, my destiny as a painter opened out to me." Without Boudin, would Monet have become the great Impressionist leader? As rhetorical as to ask if St. Paul's Epistles would have been written had not Saul been smitten by the light on the road to Damascus. Indeed, for the history of modern art, the fresh concepts set down by Boudin and the career of Monet after his enlightenment constitute a single development. It was precisely the convert's brashness that the teacher lacked, and that provided the motive power to transform Boudin's *petite manière* into a copious art against which, in one way or another, the painting of the next hundred years was to be measured.

Despite an increasing refinement in his tastes, Monet was always to retain a certain provincial roughness.

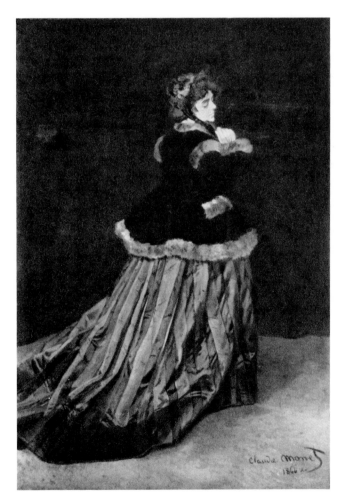

8. CAMILLE (THE WOMAN IN THE GREEN DRESS). 1866
Oil on canvas, 89 ³/₄ × 58 ⁵/₈″. *Kunsthalle, Bremen*

elevating the sketch—with the inevitable premium that it places on concentrated observation and rapid execution—to the status of a completed work of art. Boudin's reputation as a painter, however, does not derive from the cosmic naturalism so richly evidenced in his notes, but from impeccably painted studies of middle-class vacationers chatting, promenading, or sunning themselves at Trouville and Deauville. Brilliantly original, Boudin could never overcome his lack of breadth: "My touch is constrained, my color is pallid. I lack verve of execution."

Monet's account of his meeting with Boudin has a dramatic ending. He had seen Boudin's nature studies displayed in the same shop window with his own impudent caricatures (figures 2, 3). "His painting inspired me with an intense aversion," Monet confessed many years later, "and, without knowing the man, I hated him." But after they met, Monet was finally induced to try outdoor painting at Rouelles, near Le Havre. Boudin quickly set his palette and commenced to work. Condescendingly at first, and then more

9. PORTRAIT OF MADAME GAUDIBERT. 1868
Oil on canvas, 85 × 54 ³/₈″. *The Louvre, Paris*

The cultural insularity of his childhood stands in sharp contrast to the cosmopolitan training of Manet or Degas, for whom the masterpieces of the Louvre and the Renaissance tradition were as important a source as nature. Monet's naturalism cannot be separated from his distaste for urban life. "I assure you that I don't envy your being in Paris," he wrote to Bazille from Fécamp in 1868. "Frankly, I believe that one can't do anything in such surroundings. Don't you think that directly in nature and alone one does better?" He was never to become a metropolitan, though in the city his early career (which began before 1860) was marked by undeniable artistic, if not financial, success. And only in Paris could he have sharpened his ideas through acceptance and opposition, for here was the cosmopolitan milieu within which the dogma of Western culture was most keenly focused, where its conservative spokes-

men did battle with aesthetic, as well as political and intellectual, innovations.

When Monet returned to Paris in 1862 for the second time, after military service in Algeria (which he had chosen "because of its sky," see figure 11), academic art instruction was still following methods initiated in the seventeenth century. For beginners—as Monet had already learned in Le Havre under his childhood instructor Jacques François Ochard—the models were plaster casts of Roman statues. A student was taught to draw with line and neatly graded tone, and to ignore color, with the aim, not alone of copying faithfully but, if possible, of emphasizing the smooth bulks of the white figures and heads. Nor were these stringent limitations altered, Monet was astounded to discover, in the classes of the celebrated Charles Gleyre, one of the most liberal of the masters of Paris. It would be difficult to formulate a more concise summary of the academic viewpoint than Gleyre's first criticism of Monet's work: "Not bad! Not bad at all, that thing there, but it is too much in the character of the model— you have before you a short, thickset man; you paint him short and thickset. He has enormous feet; you render them as they are. All that is very ugly. I want you to remember, young man, that when one executes a figure, one should always think of the antique. Nature, my friend, is all right as an element of study, but it offers no interest. Style, you see, style is everything." But the defense of "line" and Classicism was not the only position among the old guard: the liberal, Romantic wing believed in freedom of color, rich pigment, and active brushwork. Monet worshiped the master of Romanticism, Delacroix, who like him had been stimulated by the bright light and color of Africa. With such tastes, Monet would have perhaps been wiser to have studied with Couture, as Manet did and Troyon advised; but no really "painterly" atelier existed in Paris prior to that conducted later by Monet's contemporary, Carolus-Duran. Therefore, Monet's period as an art student during the winter of 1862-63 was soon over.

The Romanticism that Delacroix symbolized, however, had been diluted and adulterated in the hands of other Salon painters, and well before Monet's arrival in Paris both wings of the Academy were attacked under the banner of Realism. Gustave Courbet's theoretical principles (which in 1861 he went so far as to

list, and had earlier dramatized in intentionally ugly paintings like the *Burial at Ornans*) included abandonment of the imaginary and abstract subjects of Romanticism and Classicism in favor of scenes of contemporary life. He further insisted that the painter should represent only actual, existing, visible, and tangible objects, and these without the slightest imaginative alteration or idealization. Courbet would have been entirely in accord with Monet's annoyance at Gleyre's criticism, which was out of sympathy with both his student's potentialities and the changing times. Boudin had felt an analogous urge to paint "middle-class people" at Trouville, and the honest depiction of modern experience was fundamental to the aesthetics of Baudelaire, the Goncourt brothers, and Zola. "Isn't a bunch of carrots—yes, a bunch of carrots—studied di-

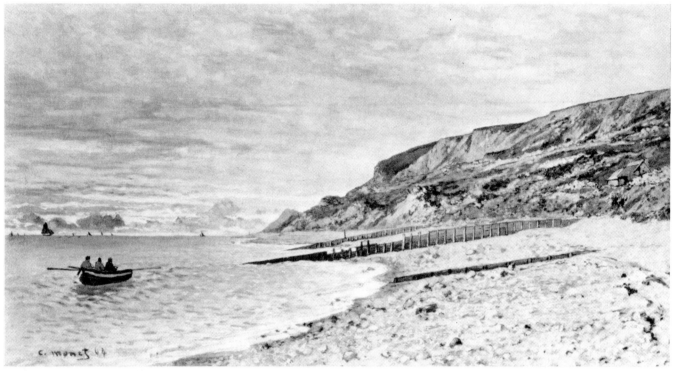

10. POINTE DE LA HEVE, SAINTE-ADRESSE. 1864. Oil on canvas, 16 × 29″. *Collection Norman B. Woolworth, New York*

11. VIEW OF ALGERIA. 1860–62. Pencil and watercolor, 5¹/₈ × 9″. *Collection Michel Monet, Giverny*

12. QUAI DU LOUVRE. About 1866. Oil on canvas, $25\frac{1}{2} \times 36\frac{5}{8}''$. *Gemeentemuseum, The Hague*

rectly, painted naïvely, in the personal way in which one sees it, worth as much as the eternal effusions of the Academy...?" the painter Claude Lantier was to ask in Zola's novel *L'Œuvre*. "Ah!" he exclaims on another page, "to see everything and to paint everything! ... Yes! the whole of modern life!"

Monet's earliest oils have been lost, but a few remaining still-life studies of the early sixties are in complete conformity with the criteria of Courbet and Zola. In one of these, he diligently rendered a lamb chop, two eggs, and a few other homely objects. Over and above a youthful striving for verisimilitude, vigorous brushwork and a sense of arrangement raise the work well above student level. Some ten years later an even simpler motif—two little fish (figure 24)—provides a pretext for a miniature tour de force of color, silvery reflections, and dexterous rendering.

The official Salon became an annual event after 1863, and, contrary to the impression given by most modern accounts, the works hung were by no means all fatuous "machines." The Dutch landscapist Jongkind— second in importance only to Boudin for his influence

on Monet—had won a third-class medal in 1852, and was a regular exhibitor. Courbet had won a gold medal in 1849 and was therefore no longer subject to the jury. Corot's landscapes (which all the future Impressionists admired without reservation) were usually received with praise. Monet's sponsors Troyon and Daubigny were regularly represented, and even a Salon of Photography was added in 1859. Between 1863 and the Franco-Prussian War, in fact, the Salons were among the most important battlefields in the fight for new styles of painting.

Nor were critical comments on innovating artists invariably obtuse and reactionary. The first time Monet submitted to the Salon, in 1865, a view of the Pointe de la Hève (possibly that illustrated in figure 10) and one of Honfleur harbor (figure 5) were accepted, and their merit was instantly recognized. "The two marines of M. Monet are unquestionably the best in the exhibition," declares Gonzague Privat. "The tone is frank, the breeze penetrating as that on the high seas, and the treatment is naïve and young." Despite Monet's youth, and though he often painted in the com-

pany of Boudin and Jongkind, his manner was already assured and personal. Excepting the early sketches of Constable, and a few beach studies by Corot, the previous history of painting offers little precedent for such objective observation and cursive placing of values. Monet's early marines record weather that, for the Channel, is fair; yet the skies are cloud-filled and the atmospheric tone (as in the *peinture grise* of Corot and Boudin) is silvery. The hues are not brilliant, but the sparkle and movement of the shore are nevertheless captured by the spontaneity of the brushwork, which varies from one passage to another. The beaches are often built up of crisp touches, or even dotted, for they are in fact not sandy but composed of sea-rounded pebbles in a multiplicity of tones. Monet's quick brush also adapted itself to the chop of open water, the pound of surf, or, heavily loaded, to banks of clouds.

The beginning of Impressionism has often been outlined as a causal chain activated by Courbet's Realism, continued by Manet, and resulting in the art of Monet, Renoir, and Pissarro; yet these steps can be as misleading as they are convenient, for Manet, though he worked from the window of a Boulogne hotel in 1869, was converted to outdoor painting in 1874 by Monet, who had already been working outdoors for more then fifteen years. Both Courbet and Manet, in fact, ridiculed Monet's attempt to complete *Women in the Garden* (page 51) in the open. The elder masters were great liberating exemplars but, however important, neither was crucial to what is most characteristic in Monet's art.

At the Salon of 1866 Monet's success was no less than triumphant for a beginner. Unable to carry through the huge *Déjeuner sur l'Herbe* (page 49), he completed—in four days—a life-sized portrait of his mistress, Camille Doncieux (figure 8), wearing a green-and-black striped skirt and a fur-trimmed jacket. It was accepted by the Salon jury (along with a study of the Forest of Fontainebleau) and became one of the most discussed works in the Exhibition. Though at the time the portrait was linked with those of Manet, it actually resembles the figure at the right in Courbet's huge *Atelier*, and remains Monet's closest approach to Courbet's manner. The petite model is viewed from above and behind without an iota of flattery. Securely planted in depth, she is nevertheless momentarily poised rather than solidly posed. Trailing her elegant gown, she has

just stopped and, half turning toward the painter, seems to adjust the ribbon on her hat with a dainty gloved hand. Eyelids lowered in an inscrutable glance, she is about to turn again and disappear. Zola and Bürger heaped praise on "The Woman in the Green Dress," but others assailed not only the painting but, oddly, the personalities of both model and painter. Both camps, however, seemed to recognize in the *Camille* a symbol—either feminine or brazen—of modern life. Zola extolled its vitality and realism: it was a "window open on nature," which seemed to hollow

13. THE BAS-BREAU ROAD. 1865
Oil on canvas, 17 × 23 ¹/₄″. *The Louvre, Paris*

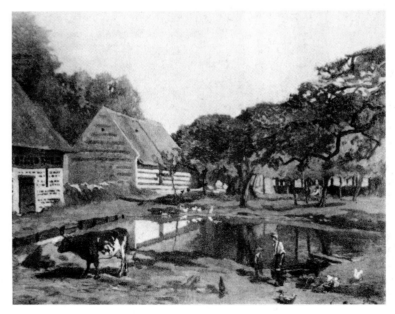

14. FARMYARD IN NORMANDY. About 1864
Oil on canvas, 25 ⁵/₈ × 31 ¹/₂″. *The Louvre, Paris*

out the wall, and Monet was a "temperament"—"a man amid this crowd of eunuchs." But to the detractors the inventive pose seemed as false as the figure, which to them resembled a deformed mannequin with a plaster head and a cosmetic mask. Albeit begrudgingly, even Monet's bitterest critics acknowledged the beauty of the masterfully rendered skirt: "dazzling as the stuffs of Veronese."

P. Martial, in his essay on the Salon of 1866, included Monet in a small group, "the painters of nature and life," who, he added, were "above all praise," and were for "the truth, in everything and always!" Manet, who invariably had trouble at the Salon, and yearned for official sanction, was jealous, especially when he was complimented on a work by Monet—that "animal" who had appropriated his name. "Manet having been politely dismissed," wrote one anti-

Realist, "M. Monet has been chosen as the leader of that brilliant school of braggadocio." With so auspicious a beginning, it is startling to discover that this was Monet's last such triumph, and that he showed in the Salon only twice more during his lifetime. Count Nieuwerkerke, the Imperial Director of Fine Arts, and other academicians realized (as Monet explained many years later) that their authority would be irreparably undermined if they gave their official approval to members of the new group; so, in 1867, Monet's revolutionary *Women in the Garden* was rejected.

There is little doubt that Monet, had he not been frustrated by officialdom and irresistibly drawn toward nature, could have been a great figure painter. The portraits of Camille and of Mme. Gaudibert (figure 9) were models for the generation of Carolus-Duran. The latter work, Monet's only important por-

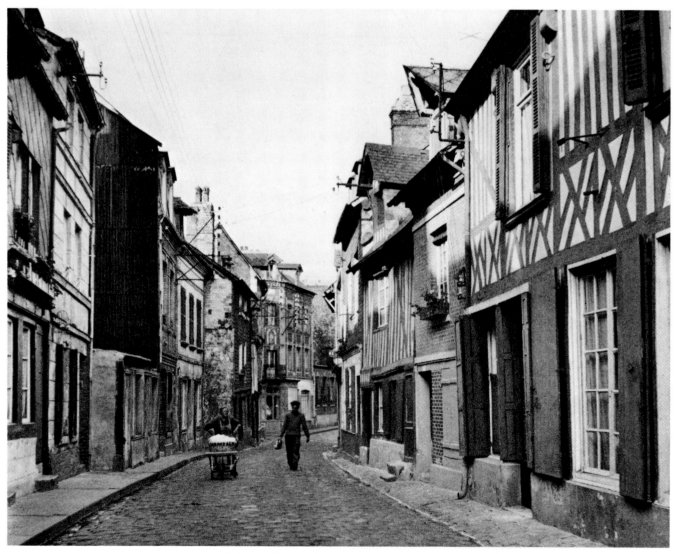

15. Rue de la Bavolle, Honfleur. *Photograph by the author, 1957*

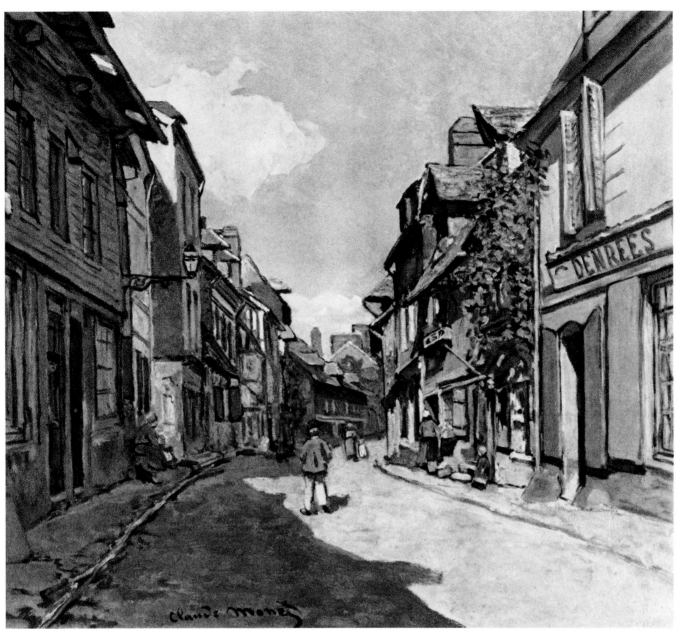

16. VILLAGE STREET, NORMANDY. About 1866. Oil on canvas, 22 × 24″. *Museum of Fine Arts, Boston (Bequest of John T. Spaulding)*

trait commission, was painted for a wealthy Le Havre business man whose patronage saved Monet from financial disaster the year after the birth of his first son. The dignified figure of Mme. Gaudibert, life-sized and wearing a fashionable gown, is fitted into a space more compressed and rectangulated than that of the *Camille*, and the handling, rougher than that of Manet at the same period, is more typical of Monet. At close range the paint surface is a patchwork of opaque and often unmodulated colors—rich reds and blues in the shawl; pink roses and a black hat on a varnished table; a bright blue background. Vitality now results from energetic handling of pigment rather than animated posing. The

Camille, in fact, is unique among Monet's portraits in its obliteration of the painted canvas surface in order to imitate the surfaces of textiles within the picture.

The *Déjeuner sur l'Herbe*, finished seven or eight months after the *Madame Gaudibert*, is the high point of Monet's interior figure painting. Few fresher or more living records of domestic life have ever been painted. Such works were the answer to the Realists' call for modernity, truth, naïveté, and temperament. It would be an error, nevertheless, to present Monet as the champion in a war against academic painting. His life as an artist was lived beyond the influence and jurisdiction of the Academy and, except for a very

17. ROUTE DE LA FERME SAINT-SIMEON, HONFLEUR. About 1867
Oil on canvas, 21¹/₂ × 31¹/₄″. *The Fogg Art Museum, Harvard University, Cambridge, Massachusetts*

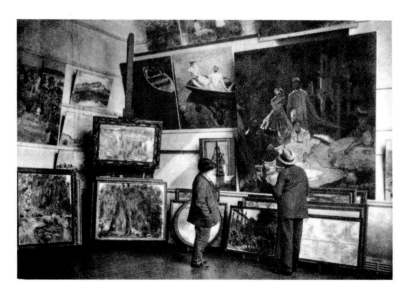

18. Monet at Giverny, 1920, pointing out the central fragment of
Le Déjeuner sur l'Herbe to the Duc de Trévise. On the same wall: two
studies of boating on the Epte (1885-88) and *Madame Monet in a
Red Capeline*. On the wall at the left: *Garden at Vétheuil* (1881) and
Mount Kolsaas (1895). On the easel: *Water Lilies* (about 1903). Near
the floor, left to right: *Water Garden at Giverny* (1917), *Weeping
Willows* (about 1918), *Water Lilies* (about 1908), *Garden at Giverny*
(1902), and *Charing Cross Bridge* (1899-1902). *(Photo Viollet).*

few occasions, outside its Salons. When Courbet and
Manet struck out against entrenched tradition—the one
with body blows and the other with the feints of a
fencer—they were at war within themselves as well as
with their environment. Yet Monet must have been
familiar with most of the viewpoints that made up
Realism and the somewhat broader concept of Natu-
ralism. Before 1860 and his military service in Algeria,
he had listened and sketched at the Brasserie des Mar-
tyrs, where the painters were dominated by Courbet;
and he was later an occasional patron of the Café Guer-
bois, where Manet was the leader and Zola, Astruc,
and Duranty were regulars. But he needed no antidote
for academic formulas. He was naïve almost by inten-
tion, had no interest in theoretical battles, and pre-
ferred to be alone with nature. If the war against aca-
demicism ever existed for him, he had won it before
he ever crossed the philistine city limits of Le Havre.

In March 1863, three years before his success with
the *Camille*, Monet had seen Manet's exhibition at the

Galerie Martinet, which included the *Concert in the Tuileries Gardens*. Shortly after, he and his friends Bazille, Renoir, and Sisley left Paris for the Easter holidays. They lodged at Chailly-en-Bière, close to Barbizon, in the picturesque Forest of Fontainebleau. On returning to town, the same group was electrified, at the Salon des Refusés, by Manet's *Déjeuner sur l'Herbe*, which employed clear flat tones rather than light and shade. It is not surprising, therefore, that the forest setting, the idea of a life-sized modern tableau, and the radical method learned on the Seine estuary began to fuse in Monet's mind. The outcome, after Monet returned to Chailly in 1865, was his own *Déjeuner sur l'Herbe* (page 49)—an uncompleted but nevertheless historic attempt to treat an outdoor social subject directly, and on a canvas twenty feet wide. Though only sketches and background studies (figures 7, 13) were worked in the open, the viewpoint demonstrated is entirely that of an outdoor painter. Except for a few studies, the forest was a new motif for Monet. The spattering of warm sunlight and cool shadow on the trembling leaves, the patterned bark of the birch trees, and the light-drenched atmosphere demanded much brighter hues than Manet had used, and a flatter and more broken handling. On Monet, therefore, the effect of the Realists' expansion of *subject matter* was to enforce changes in *form;* and his thoroughgoing application of the empirical procedure that they advocated continued the destruction of rounded bulks (still typical of the figure painting of Courbet and Millet) that Manet had begun. That Monet, a young painter almost totally without funds, should have attempted the completion of *Women in the Garden* (page 51) wholly in the open air attests not only to his technological fearlessness (of which his career offers many instances) but also to the amplitude of his imagination. Although less spontaneous in effect than the *Déjeuner sur l'Herbe*, and though the four figures are less than life-size and Camille was the only model, this was one of the first large-scale figure compositions to be executed outside the studio. Against the flat and stylized figures, background foliage is translated into dots and patches—a method also employed in the *Terrace at the Seaside* (page 53) of 1866.

The landscapes painted after 1865 share a common directness in the spotting of color tones, but the size, thickness, and rhythm of the brush strokes vary ac-

19. THE BEACH AT TROUVILLE (HOTEL DES ROCHES NOIRES). 1870
Oil on canvas, 21 1/2 × 23 1/4″. *Wadsworth Atheneum, Hartford (Ella Gallup Sumner and Mary Catlin Sumner Collection)*

20. Eugène Boudin: BEACH AT TROUVILLE. 1863
Oil on panel, 7 × 13 3/4″. *Phillips Collection, Washington, D.C.*

cording to the subject. The handling was also sometimes influenced, perhaps unconsciously, by the way the masters Monet admired had treated similar scenes. The first paintings of the Forest of Fontainebleau suggest Diaz; early farm scenes (figure 14), Daubigny and Troyon. The three views of Paris painted from the Louvre call to mind Corot, who was hostile to the new school but whom Monet nevertheless all but worshiped. Like Corot, he had the ability to draw and paint simultaneously—to articulate complicated subject matter with exactness but without lines, laying side by side painterly strokes of precisely related hue, brilliance, and value. The distant buildings in the *Quai du Louvre* (figure 12), like those in the scenes of Sainte-

Adresse, are as convincing in placement as they are delectable. More purely Monet's are the strolling figures, the carriages drawn by spirited horses, and the bill-posted kiosk. In all the landscapes painted after the *Déjeuner sur l'Herbe* and before the end of the decade, Monet is repeatedly facing new problems of visualization and interpretation that, once solved, were to become "Impressionist" technique. Should the foliage of a tree be unified to form a single bulk or silhouette (for no one can either see or paint each leaf) or should it be fragmented into variously illuminated touches? Should moving figures and vehicles be frozen and represented as the mind knows them to be, or should a formal equivalent be sought for the blurred reality of dynamic

23. MADAME MONET IN A RED CAPELINE. About 1872
Oil on canvas, 39 1/2 × 31 1/2″. *The Cleveland Museum of Art (Bequest of Leonard C. Hanna, Jr.)*

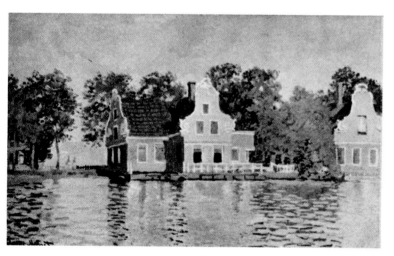

21. HOUSES AT ZAANDAM. 1871-72
Oil on canvas, 18 5/8 × 29″. *Staedel Institute, Frankfurt*

vision? Although in selecting his motifs he usually avoided those overworked by the picturesque tradition, exceptions can be found among the works painted near Honfleur. The *Farmyard in Normandy*, rendered in the "old" browns and earth greens, is almost sentimental in the narrative detail of the farm boy surrounded by ducks, working at his chores. Monet enjoyed Troyon's cows, but he must have observed their transformation into hackneyed props, for after this early instance (and the study in figure 22) they disappear from his repertoire. Yet the painting is saved by the sharp patterning of the walls, the carefully observed reflection in the pond, and a strongly painted sky. Within Honfleur many buildings date from the sixteenth century or earlier. For this reason *Village Street, Normandy* (figure 16), reminiscent of Corot and prophetic of Sisley's street scenes, is of a picturesqueness rare for Monet.

The year 1868 is marked by Monet's discovery of the Seine near Paris as a subject for painting. For the next thirteen years it replaced the seashore as his most important subject; and its waters, flowing through the tiny Epte River and the water garden at Giverny, were

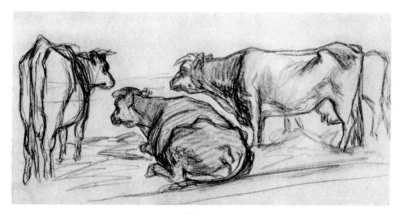

22. STUDY OF COWS. 1864.
Pencil, 9 1/2 × 18 1/2″. *Collection Jean-Pierre Hoschedé, Giverny*

22

to occupy him until the year of his death. It would be hard to overemphasize the importance of water for Monet's painting. Whipped by the wind, as in the seascapes of Belle-Ile (figures 43, 44 and page 105), it froths and crashes on the rocks in unbridled violence; in the later *Branch of the Seine near Giverny* (page 119) it vanishes in an undistorted mirror image of the sky and shore. From the beginning Monet observed and painted reflections, but they were given primary attention for the first time in the *River* (page 57). They become a means of shucking off the image of the world assembled by memory in favor of a world perceived momentarily by the senses. The river, its surface ever so slightly disturbed, enmeshes branches, hulls, or rooftops in a rhythm not their own, obscuring their mundane identity and making of them units in a new, less physical, relationship. When the motion of the water is intensified by the wind or a passing boat, the reflected image can be totally obliterated; and as appearances supplant each other in sequence the painter must choose the effect that best fits his intentions. In reflections, the artifacts so important to workaday life are transformed into abstract elements in a world of pure vision. Along the Seine, Monet learned to adapt the sizes, shapes, hues, rhythms, and impastos of his brush strokes to the fugitive images of waves and reflections. The key works in this change from coastal to fluvial subjects are those painted in 1869 at Bougival, and at the bathing and boating resort La Grenouillère (page 61). Here Monet and Renoir placed their easels side by side and, in an almost identical manner, worked out equivalents for sharp light-and-shadow contrasts, flickering reflections, bright costumes, and the quick movements of the pleasure seekers.

The development of painting in France was interrupted by the Franco-Prussian War. On July 19, 1870 (the day the Declaration was received by Prince Bismarck), Monet, Camille, and Jean were impecunious guests at the bathing station of Trouville, where Monet was painting with Boudin. The strolling figures of Monet's panoramic views (figure 19) reflect his master, but in the close-ups (page 63) the slashing boldness of

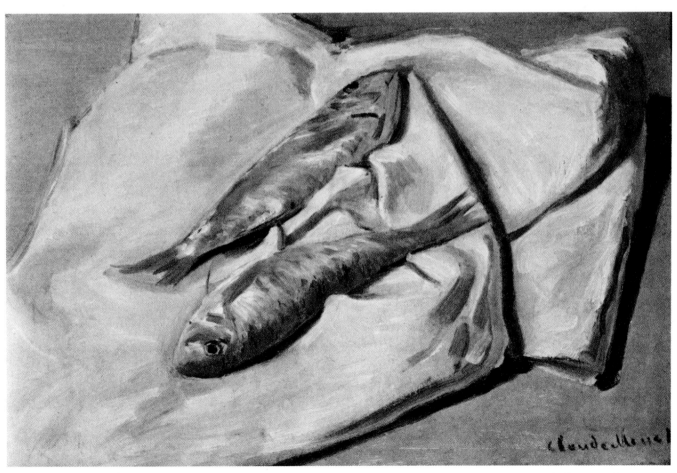

24. STILL LIFE: FISH. About 1870. Oil on canvas, 14 × 19³/₄″. *The Fogg Art Museum, Harvard University, Cambridge, Massachusetts*

the strokes evidences a breadth that, try as he might, Boudin was never to achieve. These beach sketches complete the change from the monochromatic chiaroscuro of the figures of Courbet, Millet, and Corot to open-air colorism. The two war years, moreover, can be said to conclude, neither a period of "apprenticeship" nor even of "youthful work"—for everything Monet painted after 1864 shows mastery—but of accumulation and co-ordination, during which ideas from many sources were marshaled in order to push forward the resolve born in Le Havre. It is easy to see marks of the teaching of Boudin, and that of Jongkind, in his style. But Monet's brush records few other influences: that of Corot, ubiquitous during the sixties; less demonstrably than most critics have implied, that of Courbet and Manet; that of Daubigny, and for a moment, that

of Diaz and Troyon. It should be noted also that by 1870 Pissarro's brush stroke was tending toward a small-scale divisionism somewhat more systematic than that of Monet.

By the time he fled France for London in September, however, Monet knew most of what his precursors had to offer him. It has often been asserted that in England he was inspired by Turner. "At one time I admired Turner greatly," Monet said in 1918, "today I like him much less He did not organize color enough, and he used too much of it; I have studied him." Yet Monet's only remotely Turneresque works are the late scenes of the Thames and the Houses of Parliament (figures 51, 52 and page 121), and even these are closer to Whistler's Nocturnes. Monet admired Whistler's painting, and he followed him and Manet in

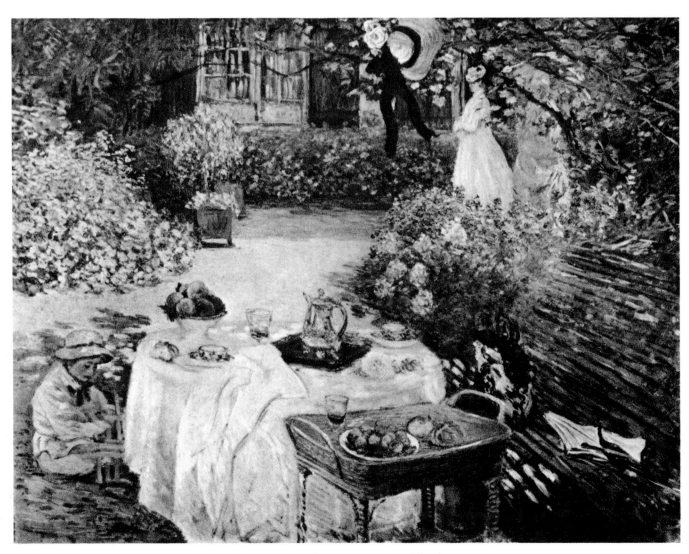

25. THE LUNCHEON. 1872. Oil on canvas, 63 × 78³/₄". *The Louvre, Paris*

24

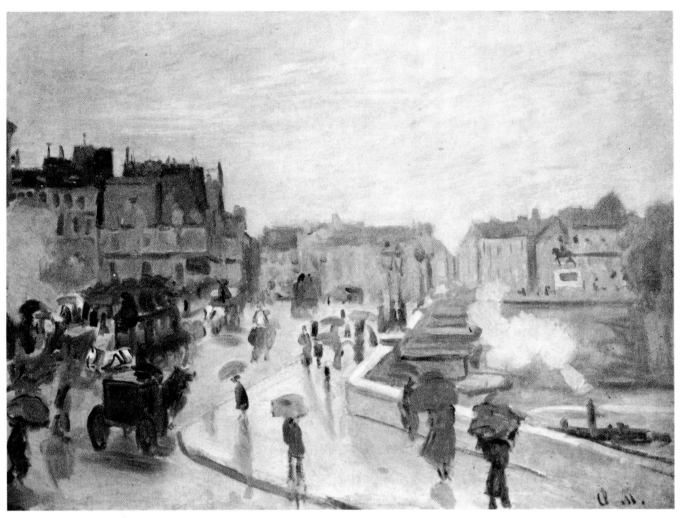

26. THE PONT NEUF, PARIS. About 1872. Oil on canvas, 20½ × 28¼". *The Emery Reeves Collection*

incorporating the flat, decorative qualities of Japanese prints into his art. In composition, the *Madame Gaudibert* and, much more obviously, the later *Japonaise* (page 79), follow a path begun by Whistler's *White Girl*, which had been shown in the Salon des Refusés of 1863. The parallel between Monet and Constable, however, is not a question of influence. Both were naturalists and innovators of a new empiricism. Because of a common dependence on direct perception, certain of their early works are startlingly akin; but Monet's Constablesque studies date before the London trip, and Constable's sketches, in all probability, were not to be seen in London at that time. Indeed, as Douglas Cooper has suggested, Monet's development might have been identical had he never seen the two English masters.

It would be hazardous to list the characteristics of Monet's style during this (or any other) period. Un-

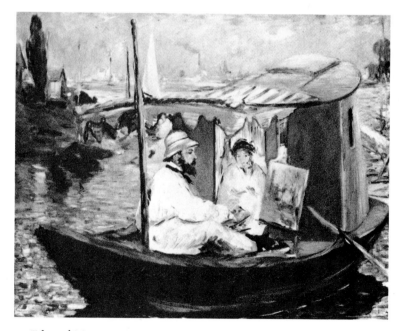

27. Edouard Manet: MONET PAINTING IN HIS FLOATING STUDIO 1874. Oil on canvas, $32\frac{1}{4} \times 39\frac{3}{8}$". *Neue Pinakothek, Munich*

25

like a studio landscapist, who inevitably repeats his own mannerisms, he was led by variations in light, atmosphere, and season to marked differences in treatment from motif to motif. These, in turn, were qualified both by the underlying trend of his evolution and by subjective factors that are hard to evaluate. Several of the English paintings of 1871, for example, are loosely constructed; yet *Westminster Bridge* (page 65), grayed and simplified by the fog, is geometric, and its flat tones are precisely stepped. Many of the Dutch studies of 1871-72 are freely handled; the picturesque shapes of windmills, sails, and rowing figures are laid in with little detail, in broad, relaxed strokes. But another group is more defined, with water crisply hatched in stripes of vermilion alternated with blue—a treatment that, as in the dotted canals of the Amsterdam pictures, already heralds the divisionist technique of the Neo-Impressionists.

During the final days of 1871 the Monet family rented a house on the Seine at Argenteuil, the region that was to yield the best-known Impressionist works. Renoir and Sisley came to paint with Monet and his neighbor Caillebotte. Manet visited in 1874, finally succumbing to the appeal of painting in the open. Earlier that same year the historic first Impressionist exhibition (page 67) had been held, under the leadership of Monet and Degas, in the former studio of the

28. Monet's Garden at Giverny
Photograph by the author, 1958

photographer Nadar, and for the next three years the group remained closely knit. Though Argenteuil is now a drab industrial suburb, during the seventies it had a carefree atmosphere. Against the background of the town, Monet painted pleasure craft at their moorings, bobbing while their skippers puttered about the decks, or racing before the breeze on regatta day. His high-keyed pigment, applied in spirited dashes, spots, and wriggles, has led to the quite indefensible notion that only at this period was painting authentically "Impressionist." But even granting, for the moment, a special historical importance to the Argenteuil riverscapes (if for no other reason, because of their similarity to the works of Renoir and other Impressionist painters), it should be emphasized how far they are from reflecting a formulated theory, and how little they smack of applied science. Although certain passages of broken color unquestionably merge when viewed from a distance (as friendly critics soon discovered), the component hues were spontaneously chosen, were as often as not mixed on the palette, and are seldom purely spectral. Monet was just as willing, moreover, to fill in a white sail or the shape of a hull with an unbroken coat of paint. Skies—quite different from those of the Neo-Impressionists, whose more uniform touches cover the entire canvas like a screen—are never in divisionist technique. Indeed, their broad treatment does not change greatly throughout Monet's career, and they are gray as often as they are sunny. But a gradual stylistic change can be discerned in these riverscapes: the large, undulating reflections of 1873 give way by 1875 to a more granular technique (perhaps influenced by Renoir) in which images are pulverized. But, as is typical of Monet's development, the change is not programmatic. He may never actually have painted (as he once remarked) "as the bird sings," but many of the Argenteuil pictures have just such an appearance of joyous spontaneity. It is this effect of freedom, among other things, that led to the false idea that the characteristic Impressionist painting is an accidental snapshot devoid of composition. Monet composed magnificently, but, because of his direct method, untraditionally. It should go without saying that he did not choose a subject or a vantage point at random, and that while the choice was being made a pictorial solution was already forming in his mind. But having made these commitments, he did not materially alter

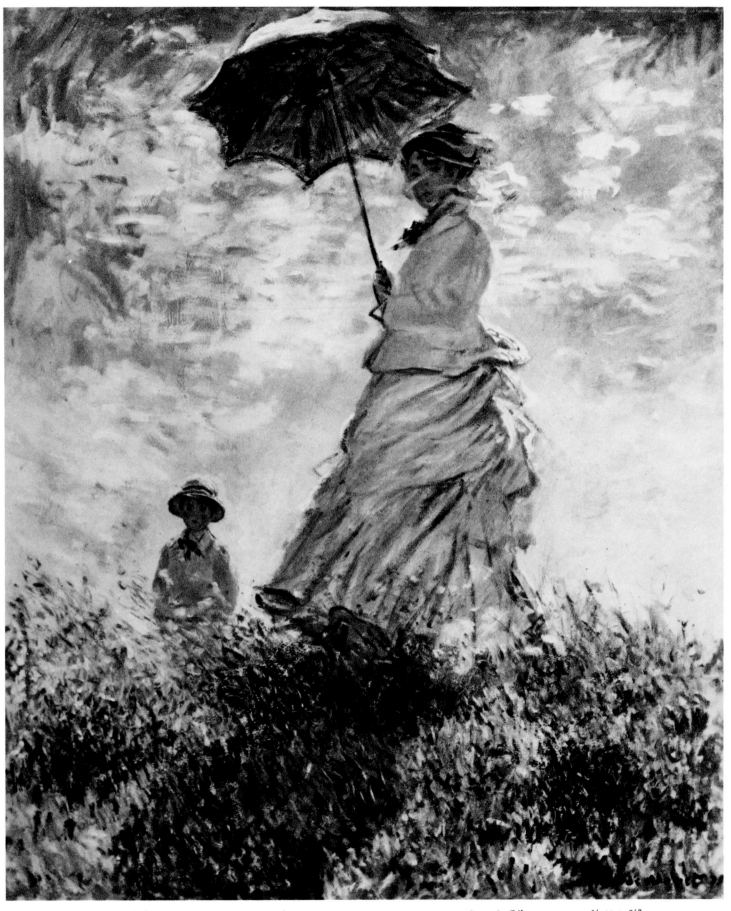

29. ON THE CLIFF (a.k.a. WOMAN WITH A PARASOL), MADAME MONET AND HER SON JEAN. 1875–78. Oil on canvas, 39⅜ × 31⅞".
National Gallery of Art, Washington, D.C. (The Mr. and Mrs. Paul Mellon Collection, Loan)

the relative positions that the stable landscape elements would have taken on a photographer's ground glass. His compositional artistry lay in precise framing, in placing mobile elements, in choosing among changing light effects, and in co-ordinating rhythms, effects of depth, plasticity or flatness, textures, impasto, and color. By its very nature, moreover, outdoor painting brings about unique means of compositional unification that make conventional devices unnecessary. Monet's landscapes are specific both in terms of time—i.e., weather, light, and season—and topography; hence, in addition to their inevitable relatedness of light and color, many other elements and qualities, such as species and seasonal characteristics of vegetation, local peculiarities of architecture, costumes, vehicles, etc., reinforce each other by a thousand affinities.

In 1874 Manet painted Monet at work on his boat (figure 27) as it rode at anchor near one of his favorite subjects. In the shadow of the cabin Camille waits patiently while her husband, sheltered from the sun by an awning and his wide straw hat, stares fixedly at and beyond his unfinished canvas, one brush poised in his

31. Monet, about 1877

right hand while the left holds several more. What activity of eye, mind, and sensibility took place as the boat tossed on the waves? Conceptual and analytical thinking must have been, as it were, in league against themselves, striving to free the senses by obliterating the practical aspect of things. "When you go out to paint," Monet was later to advise an American lady painter, "try to forget what objects you have before you, a tree, a house, a field, or whatever. Merely think, here is a little square of blue, here an oblong of pink, here a streak of yellow, and paint it just as it looks to you, the exact color and shape, until it gives your own naïve impression of the scene before you."

River scenes and landscapes are not the only subjects of the seventies. There are figure studies, for which Camille and Jean were the usual models—among them *Wild Poppies* (page 71) and the dramatically silhouetted mother and child in *On the Cliff* (figure 29). They can hardly be called "portraits," for, like the sky and grass, these figures are parts of nature. "He thinks," Lilla Cabot Perry reported in 1894, "that an eye or a nose

30. A CORNER OF AN APARTMENT. 1875
Oil on canvas, 31 1/2 × 23 5/8". *The Louvre, Paris*

28

is of no more importance than a leaf or a tree." The winter of 1875 produced a magnificent group of snow scenes (figure 32 and page 75). At that time, the complexity of Monet's personal life and his series of temporary addresses are paralleled by a variety of one-of-a-kind pictures. Among them is *Woman on a Park Bench*—a fashionable subject recalling Manet—and the strange *Corner of an Apartment* (figure 30). Jean Monet (if it is he) gazes, isolated, from the darkened room like one of the children in Henry James's *Turn of the Screw*. *La Japonaise* (page 79) was painted in 1876; in 1877, he began *Turkeys*, a decorative panel, planned for the country estate of his patron M. Hoschedé but never finished. He also continued to paint Paris scenes, including the first extended series, of the Saint-Lazare railroad station (page 81), and views of the elegant Parc Monceau. Yet Monet came to dislike Paris more and more as he grew older, and abandoned it as a subject before 1880. *Rue Montorgueil Decked Out with Flags* (page 83), painted during the Fête Nationale of 1878, is among the final views of Paris. It was selected as a motif expressly because of its urban dynamism. In the excitement, the identities of individual objects dissolve in a total experience, and into the identity of the picture itself as an object. Here Monet's historical role is again to elevate the improvised technique of the sketch—the only means of realistically painting events in process—to a final solution.

The year 1878 was especially frantic, even for Monet: he was again without funds; Camille was not well; his second son, Michel, was born; and, after a characteristic crisis over unpaid rent, the family of four—expanded, in a joint venture, by Mme. Hoschedé and her six children—rented a house farther from Paris, at Vétheuil. The road along the Seine passes Monet's house, which still stands, just before it enters the village. Painted in several versions, this approach was one of the first Vétheuil motifs (figure 38). Their color key derives from the dreary aspect of winter's end. From the faded grass, dirty splotches of snow, blackish bushes, and russet mud, Monet evolved a spattered brushwork and a minor key that seem to foreshadow Camille's illness and death in 1879. During the short Vétheuil period there are many sunny paintings of the Seine, the village, and its quaint church, but the keynote remains somber; it is sounded by the symphonic series of 1880 and 1881 representing ice on the river (page 87)—

frozen solid between the islets, piled in crushing heaps on broken and twisted trees, or moving in great chunks on the swollen floodwaters. Beneath Monet's "objective" naturalism lay not only a suppressed Romanticism but an even darker spirit. There may even be a deep-seated psychological significance in the elimination of black from his palette. When life seemed unsupportable, he saw "everything black." He associated darkness with death and had been afraid of it ever since the days of his military service in Algeria. While Camille's body lay awaiting burial he painted a study of her face,

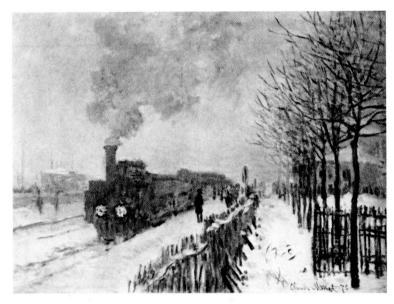

32. THE TRAIN IN THE SNOW. 1875
Oil on canvas, 27 1/8 × 31 1/2". *Musée Marmottan, Paris*

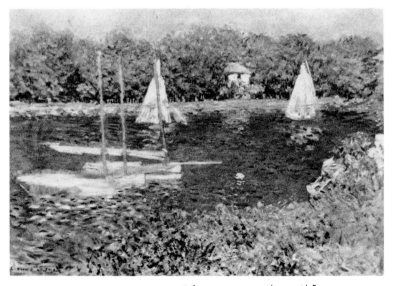

33. THE POOL AT ARGENTEUIL. 1874. Oil on canvas, 21 3/4 × 29 1/4"
Museum of Art, Rhode Island School of Design, Providence

29

appalled to find himself mechanically, and almost against his will, involved in analyzing the nuances of hue that fell on its surface.

Like the earth to Antaeus, the sea seems to have been a source of new vigor to Monet. Beginning in 1880, the Channel coast was a dominant theme for the next six years. Each year new motifs and innovations were added, resulting in a group of works that includes some of the greatest of all achievements in marine painting.

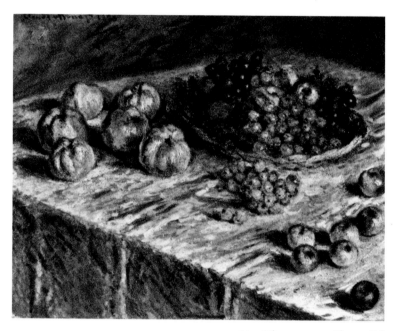

34. STILL LIFE: APPLES AND GRAPES. 1880. Oil on canvas, 25³/₄ × 32¹/₈″ *The Art Institute of Chicago (Mr. and Mrs. Martin A. Ryerson Coll.)*

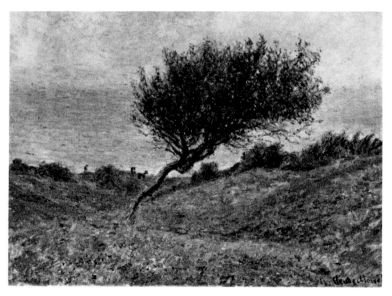

35. SEACOAST AT TROUVILLE. 1881 Oil on canvas, 23³/₄ × 32″. *Museum of Fine Arts, Boston*

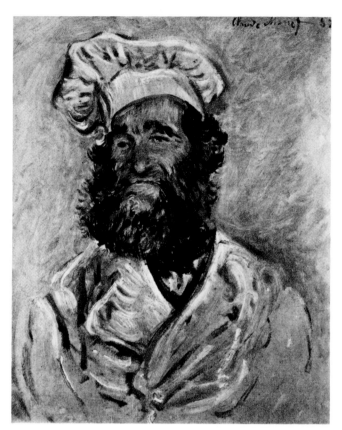

36. MONSIEUR PAUL, PASTRY CHEF AT POURVILLE. 1882 Oil on canvas, 25¹/₄ × 20″. *Oesterreichische Galerie, Vienna*

Except for some studies of a lone tree near Trouville (figure 35), the important subjects of 1881–82 were concentrated between Varengeville and Dieppe. Here the maritime plateau terminates abruptly in cliffs of soil and rock, and is cut by ravines that open toward the sea. The grassy brink afforded Monet dramatic silhouettes etched against the cerulean sea and sky (page 91), which, on a clear day, meet in a ruled horizontal—a foil for the convoluted cliff, which his brush interpreted rhythmically, exploiting each curve and break. His compositions are frequently divided into only three fields—sky, sea, and plateau—or, when the horizon is lost in mist, into only two. Linear perspective and other recessional devices are eliminated, and no attempt is made to indicate the solid lay of the terrain. Though sea and sky retain an effect of distance, individual areas have a flatness greater than that of the Japanese print. Quite unlike Hokusai or Hiroshige, however, is Monet's animation of each field by calligraphic strokes and touches of both similar and opposing hues. Seen as if through a magnifying lens, the rhythmic textures of waves, grass, branches, or ma-

sonry are enlarged and brought forward to the picture surface as in a mosaic or tapestry, so that the entire picture shimmers with light and color.

Quite differently, in the works painted along the beach, one's eye follows the shore into the distance. Nonetheless, the picture plane is reinforced by interruptions in receding lines and by the assertiveness of distant textures and colors. Seen from below or from the side, the plateau rim is harshly torn, and in the spectacular studies of the church at Varengeville (figure 37) the cliff face becomes the pretext for turbulent color combinations and rough, even passionate, brushwork. Also emotional in rendition, but gentler, are the sketches of the Pourville pastry chef and innkeeper, Paul (figure 36), and his wife. Such empathetic por-

traits, typical of Van Gogh, Kokoschka, and Soutine, are rare for Monet.

Monet left Vétheuil late in 1881, spent more than a year at Poissy, and moved to Giverny in 1883; but his trips to the shore continued, and he was attracted by more and more dramatic subjects. It is not surprising, therefore, that he returned to Etretat, where he had been in 1868. Famous for its spectacular rock formations, Etretat had been frequented by writers and painters since the eighteenth century. Protecting the beach and the valley in which the village lies, two extraordinary rocky promontories reach out into the sea: the Upper Cliff with its serrated blade and arch, and the magnificent Lower Cliff (figure 40 and page 95) with its flying buttress and two-hundred-and-thirty-foot

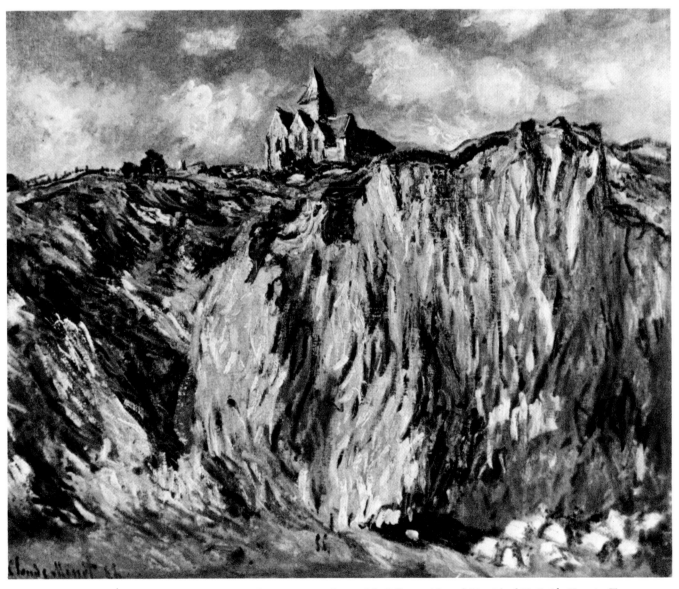

37. THE CHURCH AT VARENGEVILLE. 1882. Oil on canvas, 23^1/$_2$ × 28^1/$_2$″. *Collection Mr. and Mrs. Lloyd H. Smith, Houston, Texas*

31

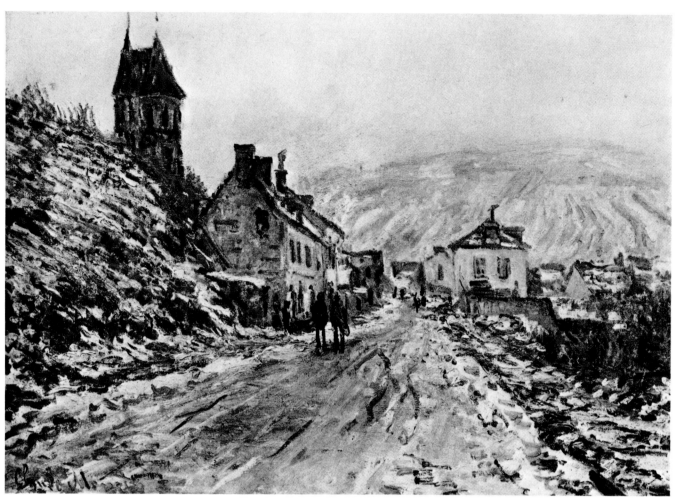

38. THE ENTRANCE TO THE VILLAGE OF VETHEUIL. 1878. Oil on canvas, 20½ × 28". *Göteborgs Konstmuseum, Sweden*

"Needle." Toward the south another bay (even.today only barely accessible) is closed by the huge arched Manneporte (page 93). In fall and winter visits between 1883 and 1885, Monet ranged the heights and the beach in all kinds of weather, painting the great cliffs, the distinctively colored fishing boats (page 101), and the thatched *caloges* in which nets were stored. These works are still "impressions," for they record momentary effects. But, to an even greater degree than before, certain canvases express nature's power, whereas others, scarcely less vigorous, emphasize light, decorative pattern, or the massive panorama of the site.

The Etretat period was interrupted in January 1884 by a trip to the Mediterranean coast, to which Monet had been introduced by Renoir the previous year. He was enchanted by the "beautiful blue water" and the exotic palm trees, and he scouted up the Nervia River to paint a flamboyantly romantic scene of a medieval bridge and a ruined castle, at Dolce Acqua. And the rising tempo of his execution was not relaxed: a quiet

grove of olive trees (figure 45) is made to gesture in enclosing curves, and the foreground branches in other views of Bordighera intertwine with a rhythm prefiguring the *Art Nouveau* which swept Europe in the nineties. In April the roseate vibration of southern light is raised to an even higher key in the canvases painted near Menton (page 97). In trying to approach the wide range of sun and shadow, Monet was compelled to use his brightest pigments.

The search for maximum brilliance came to its end in May of 1886, when Monet again visited Holland—but this time expressly to paint the tulip fields in bloom. Anyone who has seen the unique spectacle of entire fields planted in strident yellow, red, and violet will agree that here at last was a subject whose natural brilliance exceeded that of the brightest, unmixed pigments. The painter Bracquemond criticized the "crude execution" employed by Monet, "in which the impasto is so thick that an unnatural light is added to the canvas." In September, the peak of natural drama

followed that of nurtured brilliance during a stay of nearly three months on Belle-Ile-en-Mer, a primeval island outpost located eight miles at sea off the Côte Sauvage of the deserted peninsula of Quiberon in Brittany. Monet's motifs were fantastic rock formations that rise threateningly from the sea, their surfaces of schist excoriated by the howling cauldron into multiple concavities spiked like instruments of torture (figures 43, 44 and page 105). Garbed in the costume of a native fisherman, his easel weighted to withstand the wind, Monet battled day after day to render the "somber and terrible aspect" of the forces that at once frightened and attracted him. Yet in the paintings, the rock masses and caverns, placed with a cartographer's exactness, are flattened, and the crashing waves are drawn into rhythmic consonance with the rock contours by curving brush gestures. The tension is brought to a peak by the opposition of these tortuous silhouettes to the stark line formed by the merging of horizon and plateau. Who else has painted the sea with such truth, drama, and empathy?

The year 1886 was a dividing line in the art of the epoch as well as in the art of Monet. It marks the completion of Seurat's *A Sunday Afternoon on the Island of La Grande Jatte*, Gauguin's first stay at Pont-Aven, the foundation of the short-lived review *Le Symboliste*, and Van Gogh's arrival in Paris. It was the year of Monet's most significant change of direction since 1880—a reorientation mysteriously in harmony with the spirit of Mallarmé, Morisot, and Debussy. It could be described as a *détente*, a relaxation of tension; and it unquestion-

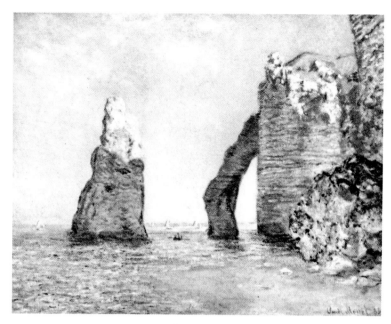

40. THE CLIFFS AT ETRETAT. 1883. Oil on canvas, 25 ¹/₂ × 32″.
Sterling and Francine Clark Art Institute, Williamstown, Massachusetts

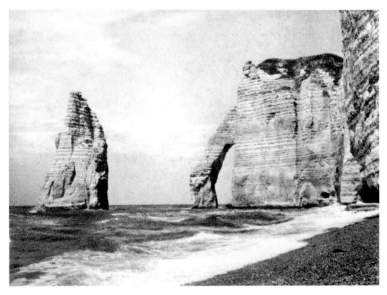

41. La Porte d'Aval and the "Needle," Etretat
Photograph by the author, 1958

ably reflects the graciousness of his life at Giverny, where he was surrounded by Mme. Hoschedé's four charming daughters. Blanche even joined her future stepfather painting in the fields. *Lady with a Parasol* (page 103) and *Boating on the River Epte* (page 107) continue the lyricism of Argenteuil, but with an added seductiveness redolent of dreamy summer afternoons, the perfumes of flowers, and the buzzing of insects. Once again in evidence is the fastidious delicacy that, like the lace cuffs that emerged from Monet's rough

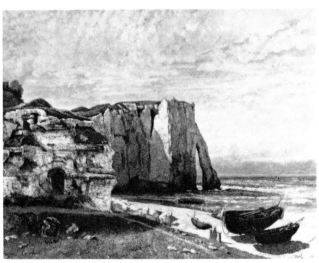

39. Gustave Courbet: LA PORTE D'AVAL. 1869
Oil on canvas, 52 ³/₈ × 63 ³/₄″. *The Louvre, Paris*

33

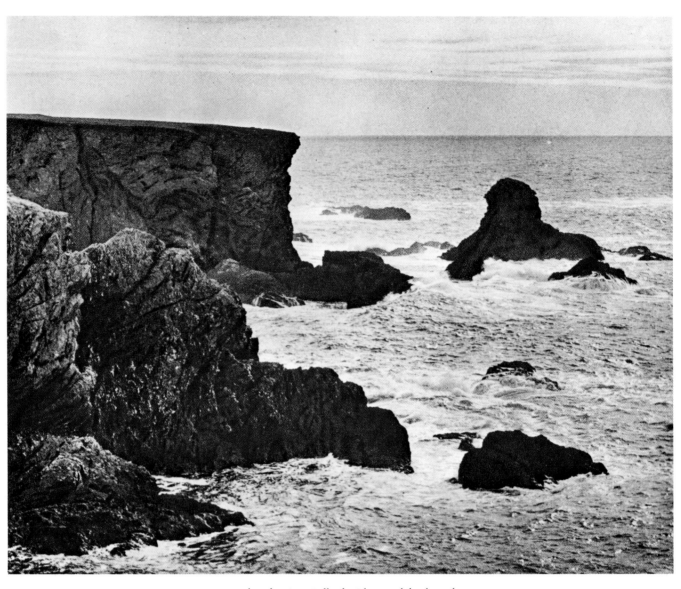

42. Le Rocher du Lion, Belle-Ile. *Photograph by the author, 1957*

jacket, counterbalanced the ruggedness of his personality. Its lightness carries over to the second group of Mediterranean views, of 1888. Screens of trees painted at Juan-les-Pins continue the curved rhythms of 1884; but measured by the "baroque" of Bordighera and Menton, their movement is "rococo." The blond color-touches—pink, lilac, sky blue, and cream—are smaller and vibrate at a higher frequency, but the canvases painted at Antibes (page 109) are sparer and more geometric.

By 1889 Monet was an established master. In June his position was secured by a joint exhibition of his work and that of his exact contemporary, Auguste Rodin. The most recent work shown was the outcome of a trip (the final expedition of the eighties) to visit the nature poet Maurice Rollinat at the village of

Fresselines in the wild valley of the Creuse (page 111). In odd bitter-sweet blue and lilac and dull darks of brown and violet, Monet captured the mood of melancholy and loneliness in what were called by Octave Mirbeau "tragic landscapes," expressing the "almost biblical mystery" of the site. He chose only a few motifs, and repeated some of them in several almost identical versions.

It has been said that Monet's art declined in the nineties; that, because of an obsessive desire to record momentary light effects precisely and systematically, his work lost the spontaneity that was the cardinal virtue of Impressionism. Such a view (quite unfair both in ignoring Monet's new achievements and in failing to recognize an innovating artist's need to make sacrifices if he is to progress) does call attention to a new

exclusiveness of intent. Much of the production of 1890–95 falls into groups, each representing one subject in many versions, as a cycle of changes in light, in weather, and sometimes of season. This cyclical method was implicit before 1880; but, beginning with 1890, when Monet began representing poppy fields, haystacks (figure 46 and page 113), and poplars on the Epte (figures 47, 48 and page 115) in series, it became an *idée fixe* that (if one can take his repeated complaints at face value) all but exhausted his energies. Since his youth his eyes had been moving from motif to palette to canvas, always making subtler distinctions of light, time of day, and weather until, by 1890, the intrinsic qualities of objects seemed of less moment to him than the gaseous luminosity in which they are immersed. Already in the late seventies the opera singer Jean-

Baptiste Faure had refused to accept a study of mist over the river because it appeared to him to be nothing more than bare canvas—though he came to covet it later. Always attempting to fit rendition to vision, Monet had found rhythms and types of brush strokes to interpret leaves, snowflakes, fog, and transitory phenomena such as shimmer, luster, and glow. After 1890, with a new overpainted and scumbled manner that gave smaller color-touches, he concentrated on the fluctuating light and atmosphere between, as well as on, objects.

In 1883 the critic Jules Laforgue had brilliantly pointed out the inherent subjectivity and mobility of thoroughgoing Impressionist procedure: the impact of visual distractions on the painter's optical sensibility as he works, and that of his own changing emotional and

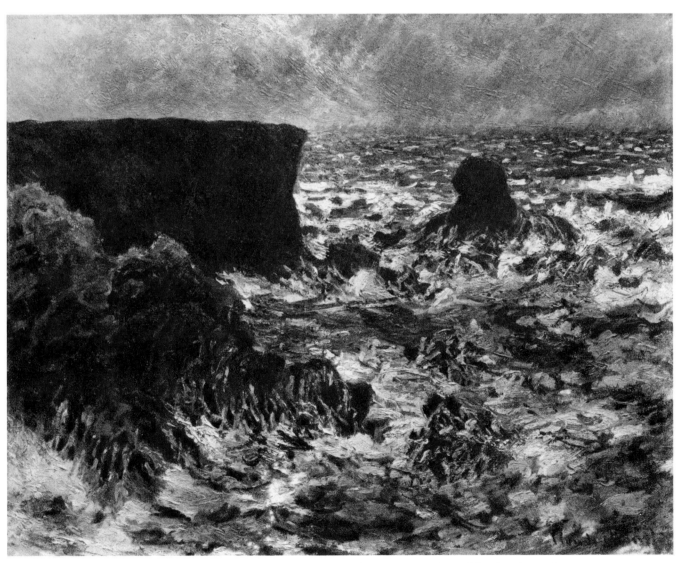

43. ROCKS AT BELLE-ILE (LE ROCHER DU LION). 1886. Oil on canvas, 23⅝ × 29½″. *Whereabouts unknown*

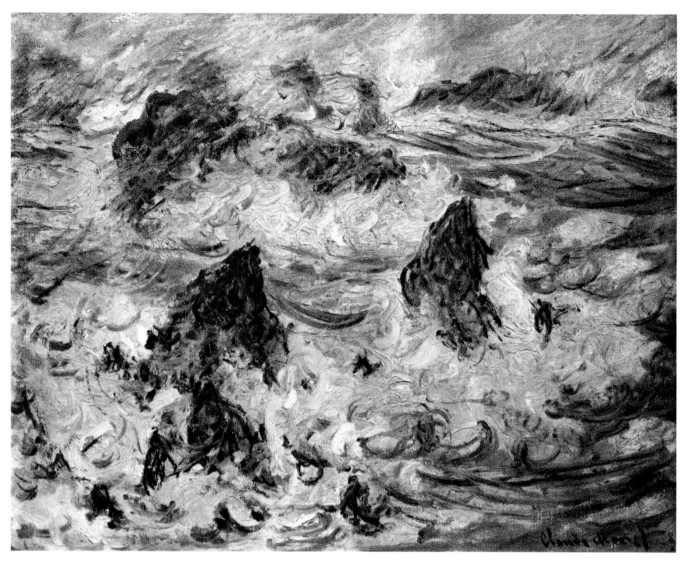

44. STORM AT BELLE-ILE. 1886. *Whereabouts unknown*

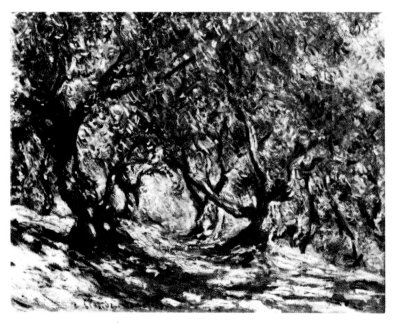

45. OLIVE TREES, BORDIGHERA. 1884
Oil on canvas, 23 ³/₄ × 29″. *Private collection, New York*

physical state. One cannot fully ascertain the degree to which Monet was cognizant of such matters, for he consistently refused to discuss theory in any detail; but he must have realized that protracted periods of visual concentration cause fatigue and hence modify vision, and the tasks he set himself appeared increasingly difficult to him. In a letter to Rollinat in 1891 he describes himself (using a phrase that was to become typical) as "always in search of the impossible." Later at Rouen, in 1892 and 1893, while anxiously striving to capture the daily cycle of light on the façade of the Cathedral, he was more than once on the verge of abandoning the entire project. It has been asserted (both in praise and blame) that the Haystacks and Cathedrals resemble scientific experiments—and one must grant a certain similarity between Monet's systematic procedure and controlled experimentation. Yet his "science" (if such

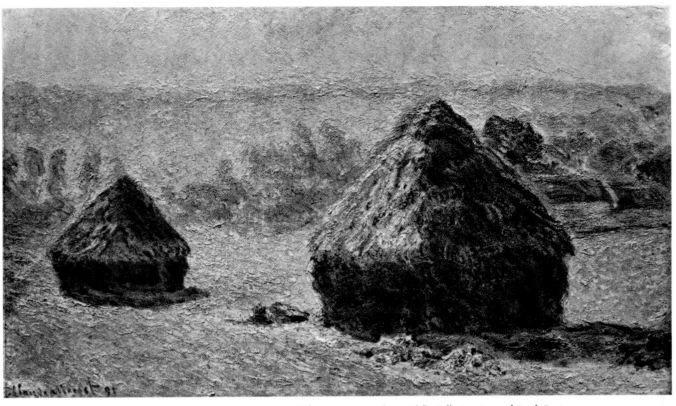

46. HAYSTACKS, END OF SUMMER. 1891. Oil on canvas, $23^5/_8 \times 39^3/_8$". *Collection Durand-Ruel, Paris*

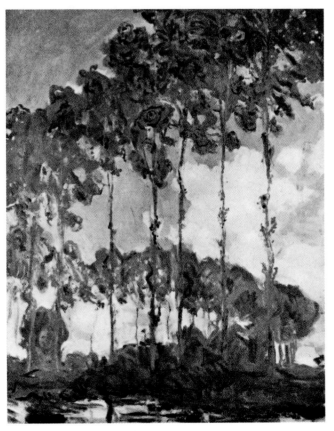

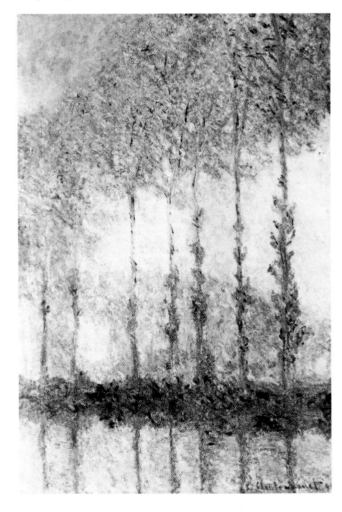

above: 47. POPLARS ON THE EPTE. 1890. Oil on canvas, $36^3/_8 \times 29$"
Reproduced by courtesy of the Trustees of the Tate Gallery, London
right: 48. POPLARS ON THE EPTE. 1891
Oil on canvas, $39^1/_2 \times 25^3/_4$". *Philadelphia Museum of Art*

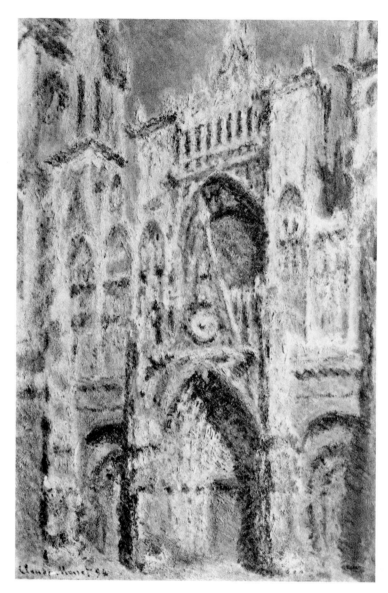

49. ROUEN CATHEDRAL. 1894. Oil on canvas, $39^1/_4 \times 25^7/_8$"
*The Metropolitan Museum of Art, New York (The Theodore
M. Davis Collection. Bequest of Theodore M. Davis, 1915)*

for all reference to rustic sentiment (so important, for example, in the works of Millet and even Pissarro) is eliminated; but he must have sensed that haystacks, built like conical or gabled huts, are *architectural* forms. At the opposite pole from his interest in curvilinear rhythms was his constant attraction—as far back as the "plus-and-minus" wharf in the early *Westminster Bridge*—to rectilinear design. Monet was working on the famous series of Poplars on the Epte at the same time as the Haystacks. He gave scrupulous attention to the spacing of the vertical trunks, their reflections, and the horizontal bar that includes both the shore and its reflected image. Yet within the geometric scheme, the wavering verticals retain a sinuous organicism.

After such a preparation the Rouen Cathedral series (figure 49 and page 117) was a logical step. The venerable façade, woven with the light and shadow of its tracery and sculpture, offered a rich yet neutral field over which color played. As Monet painted it from across the square, with sky and ground cropped, the vertical piers, arches, and linking horizontals offered an

50. Monet, about 1900

it was) remained at the furthest remove from that of the Neo-Impressionists, who deduced their method more from rules than from direct observation and felt no need to paint in the presence of the motif.

Monet, it should be emphasized, was never in closer perceptual, spiritual, or poetic rapport with nature than when he was painting the Haystacks. Their elementary form, pale color, and deep-textured surface served to modulate light without drowning its opalescence. Freed of calligraphic function, his touches and scumbles translate both the particles of light and the corpuscular sensation that results from concentrated observation, at the same time building up a surface as tactile as crushed jewels. As subjects, the Haystacks are totally neutral,

38

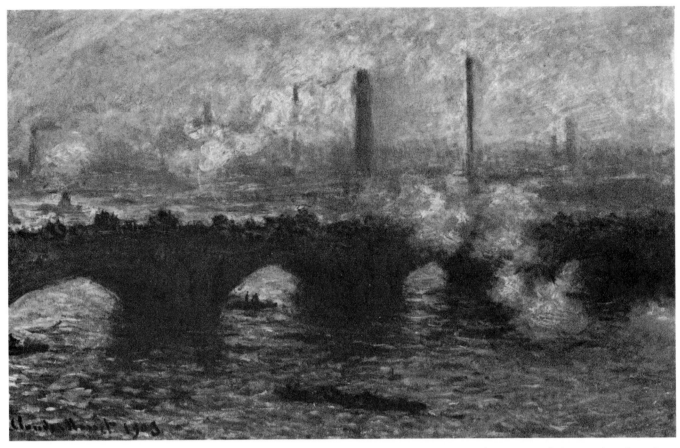

51. WATERLOO BRIDGE, GRAY DAY. 1903. Oil on canvas, 25³/₈ × 39³/₈″. *National Gallery of Art, Washington, D.C. (Chester Dale Collection)*

enduring geometric skeleton to which the most evanescent of atmospheric effects could adhere. He represented it in both gray and sunny weather, and in a sequence of moments beginning at dawn and ending at sunset. By adding white to his pigments (thus raising the color key) and by scumbles and dry glazes, Monet was able to disentangle the transparent film of light from the heavy shadows and stains on the masonry. Because of the sweeping elimination of environment, the façade comes forward, and in certain versions seems almost to merge with the actual picture surface. Art object and pictorial subject become one material fact, and illumination seems to emanate from the canvas itself. The Cathedrals were an announcement of the rectilinear design and trembling picture plane that were to characterize Cubism fifteen years later.

It is not easy to suggest—or even fully to comprehend —the variety of Monet's work and his immense productivity. Concurrent with the more famous cycles of 1889-1901 he completed, in addition to uncounted one-of-a-kind works, several other series. Among them are winter landscapes painted outdoors in Norway, in which he employed a broad style recalling that of the seventies. Just afterward he began a nostalgic pilgrimage to earlier stations: Pourville, Dieppe, Fécamp, and Varengeville in 1896 and 1897; and Vétheuil in 1900 and 1901. It was the start of a plan, never completed, to recapitulate his entire career with a few canvases of each motif.

After 1900 two ambitious projects conclude Monet's intermixed interest in atmosphere and architecture. The first was begun during three winter visits to London in 1899, 1900, and 1901, and resulted in close to one hundred paintings of the Thames. The balcony of his fifth-floor room at the Savoy Hotel directly overlooked the renowned panorama of the fog-soaked river. From this ideal vantage point he chose two motifs which he repeated in many versions. Looking toward his left, he painted Waterloo Bridge (figure 51). The individual canvases are similar in layout, but differ in illumination, the degree to which fog obscures the bridge, and the range of blues and violets that characterizes the entire group. The view at Monet's right was divided laterally by the rigid geometry of Charing

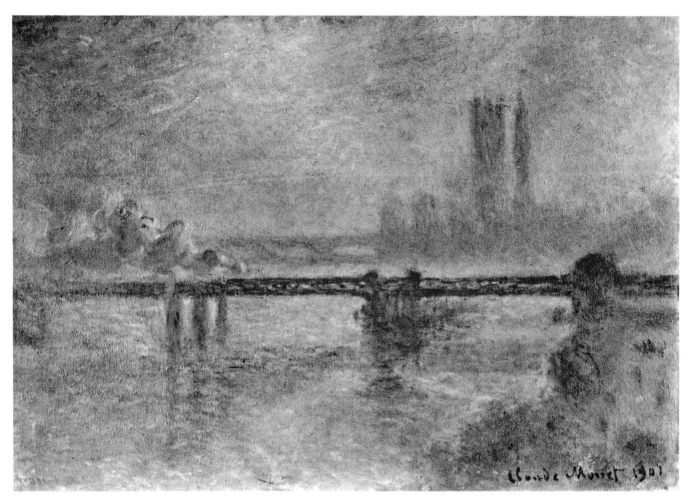

52. CHARING CROSS BRIDGE, LONDON. 1901. Oil on canvas, 25 × 36″. *The Art Institute of Chicago (Mr. and Mrs. Martin A. Ryerson Collection)*

Cross Bridge. Eerie yellow, rose, or gold light fights the mist that shrouds the distant Houses of Parliament (figure 52). These same buildings, seen from Saint Thomas's Hospital across the river, are the subject of another series (page 121). Their Gothic silhouette is romantically narrowed and heightened. Forming, with their reflections, a single unit of area, less substantial than the pulsating strokes that give tangibility and volume to the mist, the buildings brood in the glow of the late sun, dissolve, or give way to a flight of gulls or a glittering break in the clouds.

The second and last architectural group was begun during two trips to Venice in 1908 and 1909. The illness and death of Monet's wife prevented his returning to Venice, but he continued to work on the series at Giverny until 1912, cuing one canvas from another. As a consequence, the light is generalized rather than momentary. The panoramic views (figure 55) are as high in key as the Antibes seascapes, vibrating with the cerulean, pink, and cream tremolo of Venice. Except

for one Turneresque impression of San Giorgio at sunset, Monet breaks utterly with the romantic tradition of Venetian scenes, especially in the views of palace façades seen from across the Grand Canal (page 125) or the lagoon. An architecture of line, pattern, and color rather than mass, the palaces were ideally suited to Monet's concern for structure and atmosphere. Indeed, he was in complete agreement with a critic of architecture who, in an interview with Monet after the completion of the Venetian series, observed that the great Doge's Palace (figure 54) could only be explained as "impressionistic" rather than Gothic architecture: "The man who conceived this palace was the first Impressionist," Monet commented. "He did not have to paint it. He let it ride on the waters, grow out of the waters, and scintillate in the Venetian air like the Impressionist painter lets his brush strokes scintillate on the canvas to convey atmosphere to us. When I painted this picture, I wanted to paint the Venetian atmosphere. The palace that appears in my painting was only a

40

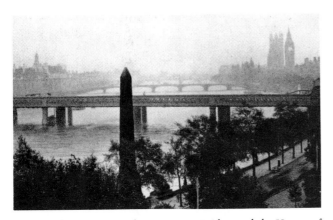

53. The Thames River, Charing Cross Bridge, and the Houses of Parliament as seen from a fifth-floor window of the Savoy Hotel, London. *Photograph by the author, 1957*
The balconies of the hotel, which once lined the Embankment, have since been removed. Monet ignored "Cleopatra's Needle" (erected in 1878), which cut his composition.

vehicle for me to paint this atmosphere. All Venice is bathed in this atmosphere. It swims in this atmosphere. All Venice is Impressionism in stone."

Yet because many of them were finished from memory, Monet disliked his Venetian canvases and painted no more architectural subjects. Other painters, critics, and the public disagreed, however, and the exhibition of twenty-nine works, in 1912, was a tremendous success.

Monet's last subject, the water garden, was made possible by the pond that was begun in 1891 by diverting a tributary of the Epte River. Although it was planned for relaxation and meditation rather than painting, he represented it, showing the newly completed Japanese footbridge, as early as 1892. Closed off from his other work—as the garden itself is from the outside world—the "water landscapes" form a separate entity, though something of their quiescent atmosphere was already implicit in the relaxation of tension that followed his return from Belle-Ile in 1886. Mallarmé's prose poem, *The White Water Lily*, had been published the year before. Later Berthe Morisot illustrated it for a book, which never appeared, but which was also to have included drawings by Renoir and Monet. The pink-gowned girls of *Boating on the River Epte* (page 107), who row (in the words of the poem) "between the sleeping vegetations of an ever narrow and wandering stream," were painted in 1887 or 1888, and in 1890 Monet wrote Geffroy about his return to painting things "impossible to do: water with grass that un-

dulates below the surface." The mood is again anticipated, late in the nineties, by the hushed series of Mornings on the Seine (page 119), the first group of Monet's works to obliterate entirely the distinction between solid reality and its reflected illusion.

With a few exceptions (which can be explained by Monet's failing eyesight and his continual anguish over the insurmountable problems he posed himself), the entire twenty-seven-year cycle of water landscapes was devoted to the theme of peace and contemplation. The garden was Monet's final haven. Seated on a folding

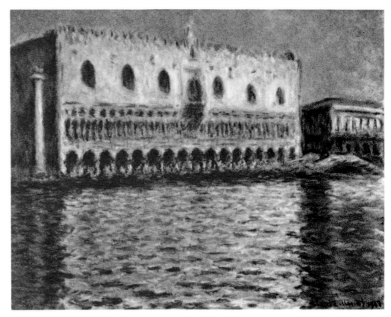

54. THE DOGE'S PALACE, VENICE. 1908(-12?). Oil on canvas, 32 × 39½"
The Brooklyn Museum, New York (Gift of A. Augustus Healy)

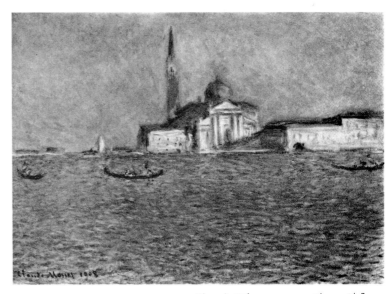

55. VENICE, SAN GIORGIO MAGGIORE. 1908(-12?). Oil on canvas, 25¼ × 35¾"
The Art Institute of Chicago (Mr. and Mrs. Martin A. Ryerson Collection)

chair or a stone bench, or leaning on the handrail of the *passerelle japonaise*, he could meditate undisturbed, transfixed by the daily opening and closing of the lily blossoms and the moving clouds mirrored in the pond's surface. Few sites (even Cézanne's Mont Sainte-Victoire) have ever been as exhaustively studied. Following the early canvases of 1892 and 1895, Monet moved close to the footbridge in the series of 1899-1900 (figure 56), readjusting his compositions from canvas to canvas like a modern photographer. In many of the versions exhibited in 1909 (page 123) the bridge, and even

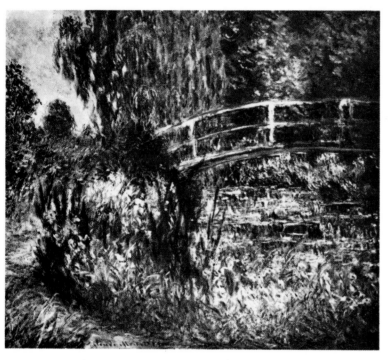

56. THE JAPANESE FOOTBRIDGE. 1900
Oil on canvas, 35 × 39³/₈″. *Collection Durand-Ruel, Paris*

57. Monet's water garden at Giverny, showing the Japanese footbridge, about 1933 *(Photo copyright* Country Life*)*

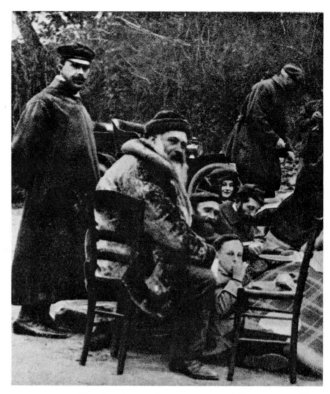

58. Monet and his family watching an automobile race at Gaillon, near Giverny, 1906. *From* La Vie Illustrée, *November 2, 1906*

the shore line, were eliminated as his gaze approached the water. Related to each other and to the frame by a meticulous geometry, the constellations of pads and blossoms are the only tangible objects. They float above inverted images of sky and trees on an invisible surface established only by their interrelationship; but the compositions are not closed, so that the imagination is free to expand in every direction.

These paintings of the water garden could have been the last, for after the interruption of the Venice pictures Mme. Monet's death left him discouraged and unproductive. Among the very few works bearing dates between 1908 and 1917 are those of the floral arches beside the lily pond (figure 60). It was on its banks that Monet was to meet regularly with his closest friend, Georges Clemenceau, during the war years. His final conception—an oval salon painted with a continuous sequence of water landscapes—was a product of their communion (though it must already have been in Monet's mind, for in 1909 the critic Roger Marx, in an "imaginary" conversation with Monet, quoted on page 122, described just such a mural scheme). Over seventy, with diminishing eyesight, the old painter was reluctant to tackle another "impossible" task. It was

the encouragement of Clemenceau that in 1914 gave him the courage for one more effort. A huge new studio was completed in 1916; after that, battling against changing light, a distaste for working indoors, and virtual blindness, Monet pushed the decoration forward for the remainder of his life, tortured even in dreams by his compulsive imagination and drive. At his death, on December 5, 1926, many related water landscapes, in various stages of completion, remained in the large studio. It was not until the year after his death that the cycle of paintings in the two oval rooms in the Orangerie of the Tuileries was dedicated, and not until after 1950 that the beauty of the remaining works was rediscovered.

Of the many attitudes that formed Monet's art, two—the belief that whenever possible a work should be completed in full view of its subject, and the aspiration toward decorative mural painting—were often in conflict. When he attempted to adapt landscape or still-life subjects to a decorative scheme, or to enlarge easel pictures to mural size, he was usually unsuccessful, because the vitality of direct painting was lost.

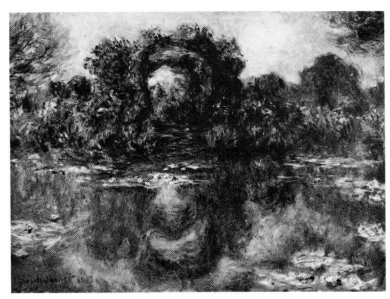

60. THE FLOWERING ARCHES. 1913
Oil on canvas, 29 × 39³/₈″. *Whereabouts unknown*

Though he may not have realized it at first, the creation of the water garden finally fused these goals. As a master gardener he had created a total motif that was both decorative and muralesque when painted directly. In the oval rooms of the Orangerie one is surrounded—as was Monet in his sequestered garden—by a fluid universe at once limitless and enclosing. Described by the painter André Masson in 1952 as the "Sistine Chapel of Impressionism," the rooms present a new type of space and an unprecedented conception of a painted interior. In the second room the shoreless water is framed by trunks and festoons of willow. The first room (figure 62), through which one both enters and leaves, is without even this frame of reference. The few lily blossoms—of pink, white, and pale yellow—stand out in giant unretouched strokes. The two end panels close the cycle. The one near the entrance is a rose and saffron reflection of an unseen sunset; the other is of a blue at once intense and deep, with a peace almost too final.

59. THE WATER GARDEN AT GIVERNY. 1917
Oil on canvas, 46¹/₁₆ × 32⁵/₈″. *Musée des Beaux-Arts, Grenoble*

Like many of the related canvases so recently spread among the world's museums and collections, these enclosing waterscapes have a new, symbolistic overtone. Monet had always sensed a level of reality on the threshold of, or inaccessible to, vision; yet, except in rare instances, his art never crossed the border line between appearances and metaphysics, or between Impressionism and expressionistic or abstract painting.

43

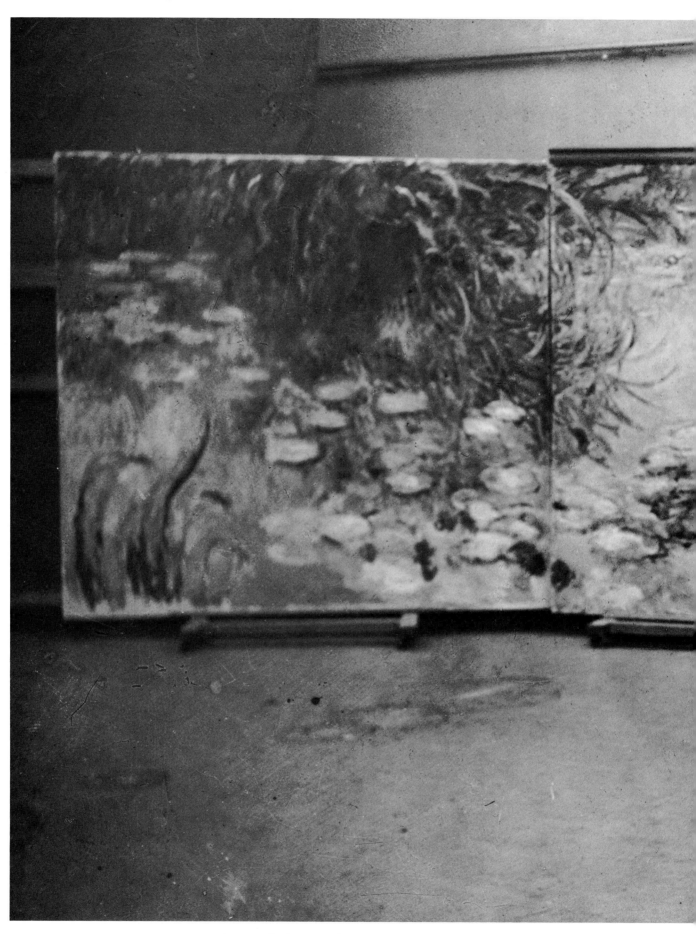

61. Monet in his large mural studio, about 1920 *(Photo Viollet)*

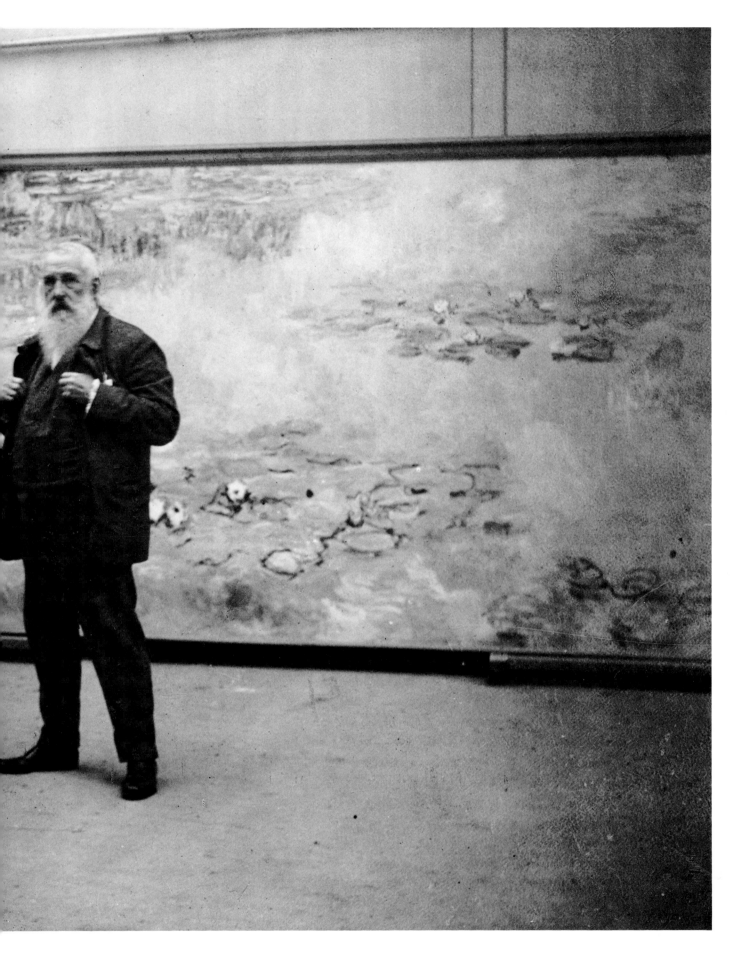

62. WATER LANDSCAPES (first room). About 1919-26. Oil on canvas. *Musée de l'Orangerie, Paris*

Indeed, just a few months before his death he reaffirmed his belief that Impressionism "was only immediate sensation," and "a question of instinct." In June 1926, he again emphasized that he had "always had a horror of theories," and that his only merit lay in painting "directly from nature, striving to render my impressions in the face of the most fugitive effects." It was Clemenceau, who collapsed from emotion for the only time in his life at his friend's funeral the following December, who recorded (one hopes correctly) what may be Monet's only statement of his metaphysical naturalism: "I am simply expending my efforts upon a maximum of appearances in close correlation with unknown realities. When one is on the plane of concordant appearances one cannot be far from reality, or at least from what we can know of it.... Your error is to wish to reduce the world to your measure, whereas, by enlarging your knowledge of things, you will find your knowledge of self enlarged."

COLORPLATES

Painted in 1865–66

LE DEJEUNER SUR L'HERBE

(THE PICNIC; fragment)

Oil on canvas, 97¼ × 85¼"

Private collection, Paris

This animated scene of an elegantly dressed party about to lunch in a sunlit forest clearing is a fragment of a huge composition, approximately fifteen feet high by twenty feet wide, which Monet never completed. Few themes evoke the leisurely charm of French country life as poignantly as that of the woodland picnic, and few settings have been dedicated to bucolic pleasure so completely, or for so long a time, as the Forest of Fontainebleau. Accompanied by Renoir, Sisley, and Bazille, Monet spent the Easter holidays of 1863 painting in this ancient setting at Chailly-en-Bière. Back in Paris, he saw Manet's *Déjeuner sur l'Herbe* at the Salon des Refusés. Two years later, again in the spring, Monet returned to Chailly intent on producing a life-sized figure composition that would be truer to nature than those of Manet and Courbet. To complete it in the woods was out of the question; the studies, therefore, would be made in the open and the final work accomplished indoors. In May he wrote to Bazille, begging him to come, give advice on the choice of a landscape setting, and serve as a model. Unlike Manet (who had patterned his *Déjeuner sur l'Herbe* after Raphael and Giorgione), Monet began with landscapes, such as the *Bas-Bréau Road* (figure 13), and then conformed his figure group to nature. The lanky Bazille finally arrived in August: he can be recognized here, wearing a derby, at the apex of the central group; stretched out at the right in the smaller replica of the composition in Moscow (figure 6); and again, carrying a cane, in the open-air study (figure 7) for the couple at the far left of that version. The romance of Monet and Camille was in its first flush, and it was she, it would appear, who posed for all the female figures. The bearded and rotund figure seated at the left in this fragment (and replaced by a younger man in the Moscow version) is identified by Geffroy as the painter Lambron, but it is hard to ignore the resemblance to Courbet. It was Courbet's criticism that discouraged Monet, and he abandoned the large canvas, leaving it as security for unpaid rent. Several years later, when Monet returned to repossess his work, it was found rolled up and moldering in a cellar. Besides this central fragment, which Monet especially treasured (and which he is showing to the Duc de Trévise in figure 18), the left-hand section was also preserved, and is now in the Louvre.

Fortunately, the Moscow version retains the satisfying grouping, natural scale, and sylvan atmosphere of this historic composition; and the fragments show how boldly Monet interpreted dappled forest sunlight and shadow in areas of flat color, passages of broken brushwork, and bright accents.

48

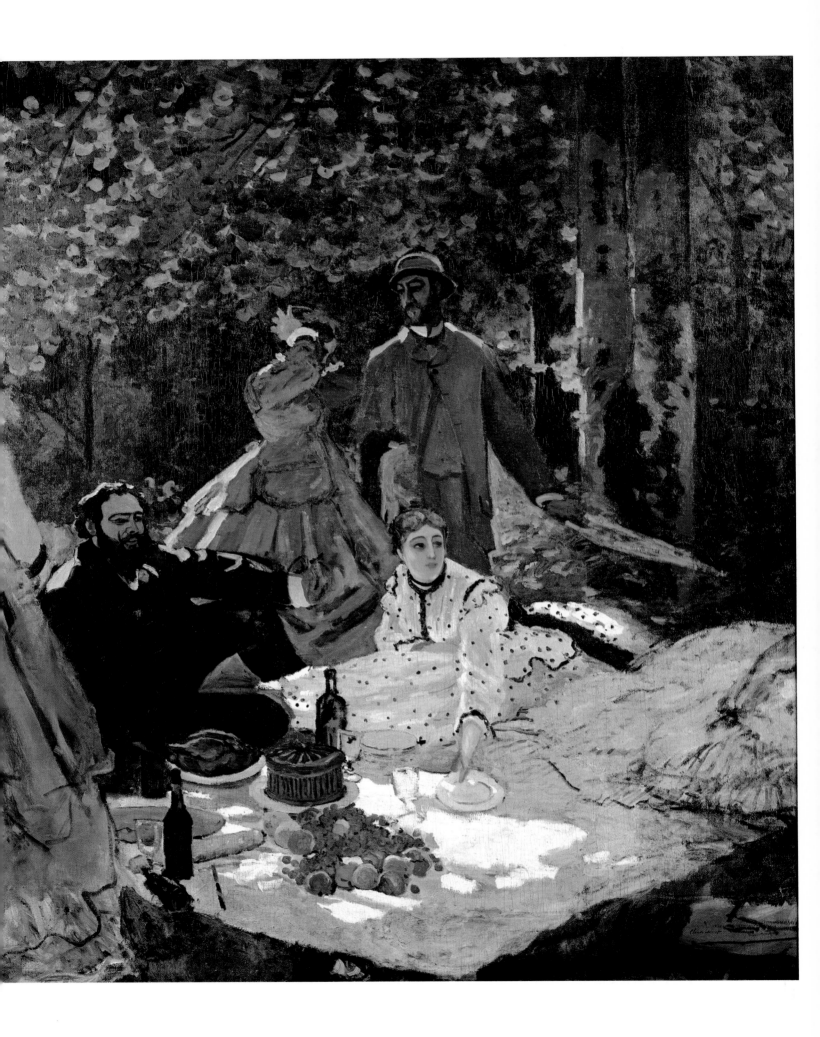

Painted in 1866–67

WOMEN IN THE GARDEN

Oil on canvas, 100½ × 80¼"

The Louvre, Paris

Monet has attested that the *Women in the Garden* was painted "on the spot and after nature" in the garden of a house he had rented (but could not afford) at Ville d'Avray. But it would appear that Camille, wearing costumes used the previous year for the *Picnic,* was the only model. In order to reach the upper sections of the tall canvas, Monet was forced to dig a trench into which it could be lowered with a rope and pulley. Courbet, who visited from time to time, was amused by the odd apparatus, and was puzzled because Monet refused even to touch the foliage background when the sun did not shine.

For Monet's contemporaries, this was a challenging picture. Without the slightest regard for traditional methods of modeling flesh and drapery, he had recorded the true effect of outdoor light on the figure, noting how the face of the seated girl was illuminated from below by a blue reflection from her white gown. And how delicately the warm skin tones shone through the transparent sleeve of the figure at the far left! Yet the literalism of *Women in the Garden* should not be overemphasized: its composition is meticulously ordered, and the treatment of the modish figures and ornamented gowns as pastel silhouettes set off by nuclei of bright colors is as stylized as a Watteau *fête galante.* The design is beautifully co-ordinated by a series of ovals which swing around the lap of the seated figure; and the red-haired figure at the right, as she moves around the central axis provided by the tree trunk, defines a similar curve in depth.

In late summer, after Monet was forced to slash some two hundred canvases to keep them from his creditors, he and Camille fled Ville d'Avray, and the painting was completed in Honfleur. Bazille was touched by their distress, and in January 1867 he purchased *Women in the Garden* for the large sum of 2,500 francs, to be paid in monthly installments of 50 francs each. (The work may even have been a commission, and photographs of Bazille's sisters taken at the family château near Montpellier may have given Monet his charming theme.) Rejected by the Salon of 1867, the canvas was shown in Latouche's shopwindow and was ridiculed by Manet. It was he, ironically, who acquired it from Bazille's father in 1876, though it later returned to Monet's possession. In 1921 the French Government approached him, to make a major purchase. He had never forgotten the slight given him by the Salon jury in his youth, and insisted that the wrong be righted; as a result, it was this painting for which the State had to pay 200,000 francs.

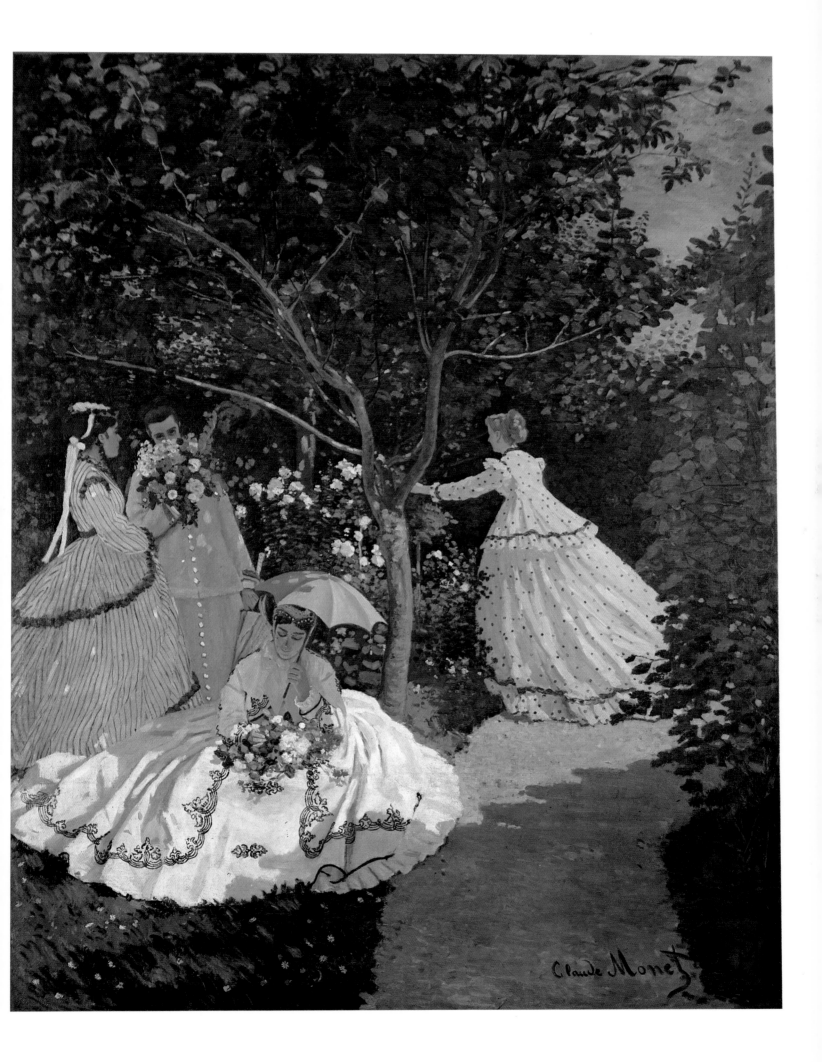

Painted in 1866

TERRACE AT THE SEASIDE, SAINTE-ADRESSE

Oil on canvas, 38½ × 51"

The Metropolitan Museum of Art, New York

(Purchased with special contributions and

purchase funds given or bequeathed by friends

of the Museum, 1967)

It was probably in 1845, when Monet was five years old, that his family moved from Paris to Le Havre, where his uncle, M. Lecadre, was a successful ship chandler and wholesale grocer. The *Terrace at the Seaside* provides a valuable record of the family circle that disapproved so strongly of Monet's profession and way of life. New light is thrown on this well-known work by an entry of 1920 in the journal of René Gimpel, a collector who visited Giverny on several occasions: "Monet showed us a photograph of one of his canvases, which represents his father looking at the sea; and the canvas should be in America. . . . He pointed out to us that on each side of the composition there is a pole with a flag and that, at that time, this composition was considered very daring."

Stylistically, the *Terrace at the Seaside* lies on the border line between a free, perceptual realism and Impressionism. Like the subjects of Boudin and Bazille, it is middle-class genre. The group is dominated by the figure of his father, one of the most solidly modeled figures of Monet's career. Combined with the downward-looking view and the structural emphasis provided by the flags and the balustrade, the angular position of his rustic chair serves to set him apart from the other—plainly less significant—figures. The grayed blue sky is flatly painted, though the bright green-blues of the sea are laid in with freer brush strokes. Against this background, the profiles of sailboats and ocean-going vessels, which Monet knew so well, appear as thin silhouettes. It is especially in the flower gardens that Monet, by intensifying a treatment used in other subjects of the same period, prefigures Impressionist handling by separating the color tones of blossoms, leaves, and shadows, restating their appearance in patches of bright red, green, yellow, and violet. In his endeavor to capture the full chromatic range of outdoor color, Monet was led by motifs, instinct, and experiment, and not by theoretical principles.

52

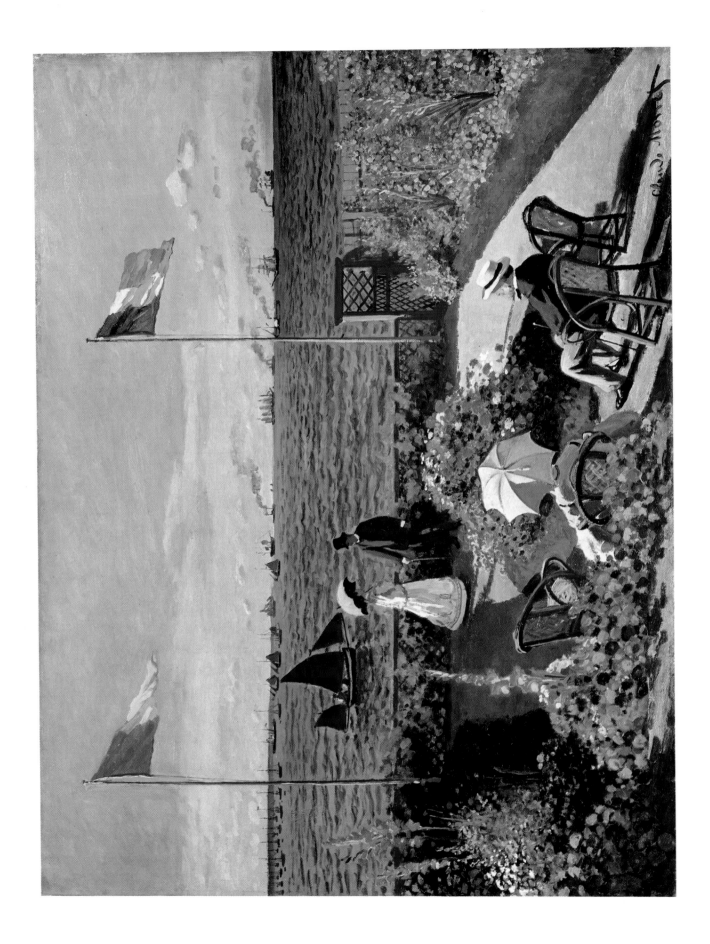

Painted in 1867

THE BEACH AT SAINTE-ADRESSE

Oil on canvas, 29½ × 39¾"

The Art Institute of Chicago

(Mr. and Mrs. Lewis L. Coburn Memorial Collection)

When Monet was a child, the beach between Le Havre and Sainte-Adresse was
one of his favorite haunts. After his introduction to outdoor painting by Eugène
Boudin, he made many studies of this shore which he knew so intimately. Few
previous works in the history of painting approach them in directness and veracity.
Though the young painter often worked beside Boudin and Jongkind (whom he
had met, not far from this spot, in 1862), his style was already more vigorous than
Boudin's and more probing than Jongkind's.

Of all types and periods of Monet's painting, these early beach scenes seem
closest to "normal," i.e., casual, vision. He was unfettered by traditional formulas,
and relied instead on an innate optic sensibility. (Indeed, the figure gazing sea-
ward through a telescope would seem to suggest an affinity between visual
sensitivity and the demands of life near the sea.) Were his images not enriched by
vigorous brushwork, selective placing of mobile elements, and an intangible
quality of artistry, one would say that he perceived objects as a camera does—in
colored patterns rather than solid masses. His almost careless rendition of the three
fishermen, however, shows far less attention to descriptive detail. Quite naturally,
such a predisposition leads, as in the work of Boudin, to an attractive juxtaposition
of unmodeled color patches: ripe yellow, blue, green, red, tan, and off-white in
the boats and figures on the beach; more neutral mixtures, like those of Corot, in
the distant buildings.

Though entirely unsystematic, perspective recession is at this time more impor-
tant than it will be in Monet's later work. The horizon is low; forced back by the
large boats on the beach, the boats on the sea diminish in ordered steps. The roof
of clouds proceeds rapidly toward the horizon, and the free touches that accent
the sea and beach change character, become smaller, or dissolve as they recede.
The air is clear, for Monet's eyes had not yet commenced their analytical scrutiny
of atmosphere, nor his brush its interpretation by granular rendering. Later on,
the horizon will usually be raised, distant objects and textures will be pulled
forward, and the surface of the picture will materialize in fields of fragmentary
touches. At this time, a splendid moment in Monet's career, the surface is still
completely transparent.

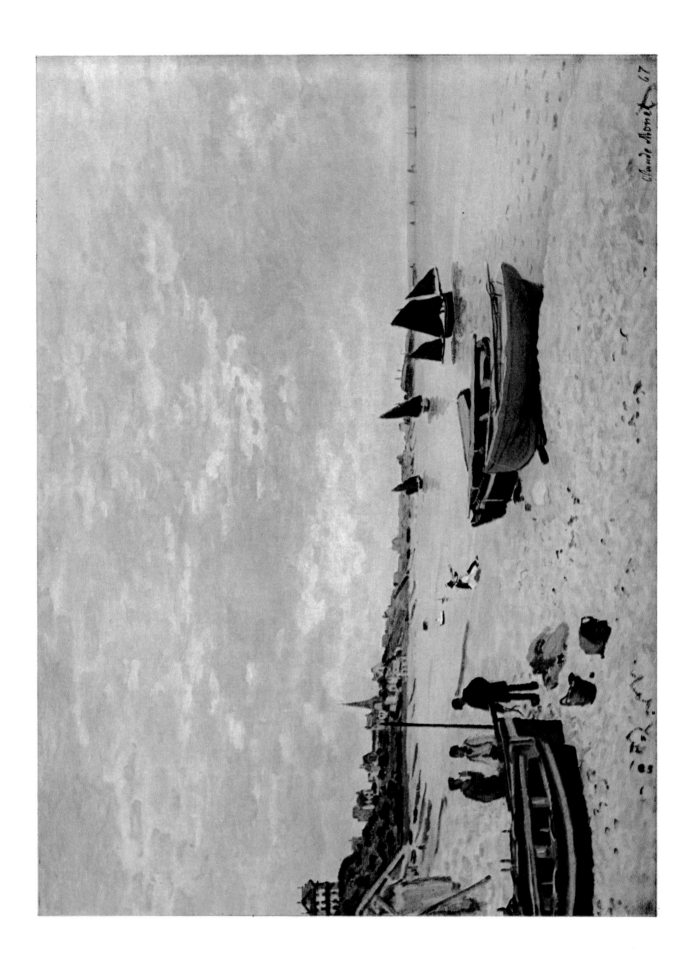

Painted in 1868

THE RIVER

Oil on canvas, 32 × 39½″

The Art Institute of Chicago

(Potter Palmer Collection)

The *River* is one of the first of Monet's works that can properly be described as an "impression." Its aspect denotes a wholly perceptual experience: the color areas are flat and simple, as though observed only for a moment or through half-closed eyes. Except for the figure (probably Camille) seated on the bank, the entire foreground is a perforated screen of cool shadow behind which the glittering sky, shore, and river seem suspended. The tree trunks are flat bars rather than columns, and the one at the left is broken by the spotting of sun through leaves; the foliage is a green and yellow tapestry of which the smallest unit is a brush stroke rather than an individual leaf; and along the foreground bank unidentifiable wild flowers provide pretexts for yellow and white touches. Objects that Monet chose to emphasize (such as the rowboat) are described with ease and precision; but to other detail (such as the clothing spread on Camille's lap) he gives little attention. Only gradually, and never positively, does one discover that the spots of color across the river and between the tree trunks are boats and human figures—as if Monet had recorded what struck his eyes without pausing to identify it. At this point in Monet's career, however, "local" hues (the body colors of objects) are not greatly altered, as they will be later on, by atmospheric ambiance.

Here, for the first time, Monet gives a structural role to reflections. The inverted image of a hidden building provides a rectangle which solidifies the design and echoes the architecture along the shore. Delightfully spontaneous though the total effect is, the composition is controlled by strong horizontals, by the tree trunks, and by parallel diagonals, which tie foreground to distance. It is focused, moreover, by the tiny rectangular window near the center of the picture, which detaches itself from its wall to become a geometrical detail within the screen of foliage. The foreground figure—almost too heavy for its position—is effectively counterbalanced by the buildings at the right.

Life was pitifully difficult for Claude and Camille in 1868. Monet had suffered temporary blindness during the previous year, and their first child had been born under trying circumstances. Cut off by Monet's family, they were penniless; he writes of a search for temporary shelter for Camille and Jean; that, now alone, he has nowhere to sleep; and that "I was so upset yesterday that I had the stupidity to throw myself in the water." How far this lyrical impression of French life seems from such painful realities!

56

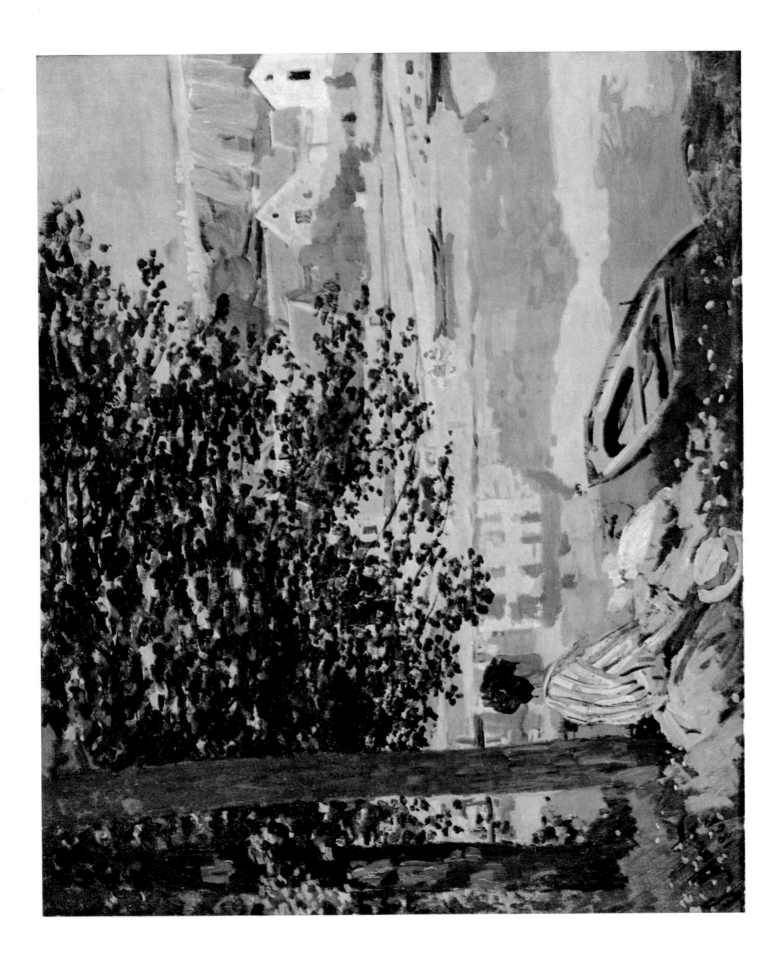

Painted in 1868

THE LUNCHEON

Oil on canvas, 75⅜ × 49¼"

Staedel Institute, Frankfurt am Main

The repeated crises through which Camille and Monet passed after the birth of their first son, Jean, were temporarily halted during the summer of 1868 by Monet's patron, M. Gaudibert, whose financial assistance enabled them to live comfortably in a small house (possibly at Etretat) near Fécamp. "I am surrounded here with everything that I love," Monet writes to Bazille. He tells of happy days spent on the beach or in the country, and of returning in the evening to find "a good fire and a cozy little family in my cottage. If you could see your godson —how sweet he is at present. It's fascinating to watch this little being grow, and, to be sure, I am very happy to have him. I shall paint him for the Salon, with other figures around, of course. . . ." He speaks further of a proposed "interior with a baby and two women"—a project realized, it would appear, in the *Luncheon*, the last of Monet's large figure compositions.

After 1855 the demand of Realist critics was for truth to life. With Corot as an example, landscape painters were more concerned with truth of tone. Few pictures of the sixties, however, achieve both social and optical naturalism more successfully than this one. Edouard Manet also painted a *Luncheon* in 1868, with which Monet may have been familiar, for it has been said that he posed for a preparatory drawing. Manet's picture is arranged with characteristic aestheticism and ambiguity. Quite differently, each detail of Monet's *Luncheon* is clearly essential to its domestic theme: the maid has set the table with a typical French midday dinner; Camille gives affectionate attention to little Jean, whose toys are strewn beneath the chair at the left which holds her sewing. Although Monet is not present, the picture is almost a self-portrait, for his personality dominates the room. His place at the table is carefully set with glass, cutlery, his ringed napkin, boiled eggs, an end cut of bread, and his copy of *Le Figaro*. Near the window, which floods the table with light, a visitor gazes benignly at the mother and child.

In individual passages, realism is maintained not by niggling detail, but by large strokes, more vigorous than those of Manet at the same moment, and of extraordinary veracity of color tone: the mesh of the visitor's veil, interpreted as a subtle change in flesh color; the variety of "whites" seen in light and shadow; the exact spring green of the lettuce; the brown of varnished wood; the flour-dusted crust of bread; the opalescence of the juicy grapes; and, through the thick glass cruets, a precise differentiation between the tones of oil and vinegar.

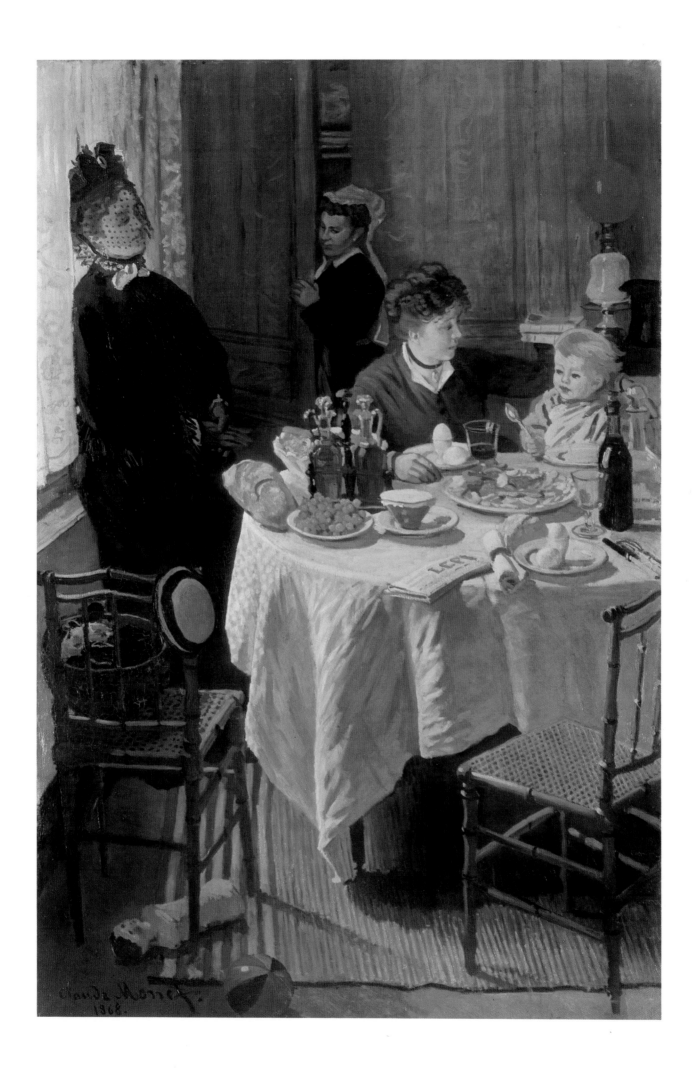

Painted about 1869

LA GRENOUILLERE

Oil on canvas, 29⅜ × 39¼"

The Metropolitan Museum of Art, New York

(Bequest of Mrs. H. O. Havemeyer, 1929.

The H. O. Havemeyer Collection)

In 1868, Renoir began painting at a celebrated river resort close to Bougival known as La Grenouillère. Here an uninhibited band of pleasure seekers boated, bathed, and dined at a nearby restaurant operated by Père Fournaise, whom Renoir portrayed "in his white café vest, in the act of drinking an absinthe." During August 1869 Monet joined Renoir. "The world knew how to laugh in those days," Renoir recalled many years later. "Machinery had not absorbed all of life; you had leisure for enjoyment and no one was the worse for it! . . . I always stayed at Fournaise's. There were plenty of pretty girls to paint. . . ." From the adolescence of Impressionism few images are more captivating than that of the two friends, Renoir and Monet, twenty-eight and twenty-nine years of age, their easels planted side by side on the shore, battling with the scintillating brilliance and movement of the sun, the water, and the gay costumes. In their extant studies (at least three by each of them), one can still revel in carefree exuberance, the splash of oars, and the sound of voices across the water. Here, surely, is the painting of *la vie moderne*—that energized contemporaneity championed by Baudelaire, Zola, and the Goncourt brothers. "I have chosen the modern epoch," writes Monet's friend Bazille, "because that is what I understand the best and find the most vital for living people."

At the right of the radiating composition, figures gather on a floating pavilion on the outside of which BOATS FOR RENT is lettered. From it, across a narrow catwalk, figures pass to the shade of the circular "camembert"; and at the left, almost indistinguishable from their own reflections, bathers stand waist-deep in the Seine. Monet has continued the extemporaneous handling initiated in the *River* the year before; but, challenged by the pace of the visible and audible activity around him, the tempo of his brush is faster, the strokes are broader, and the contrasts of value and color are bolder. The dancing light and shade on the lapping water has enforced a technique almost as broken and open as the technique Monet was to employ in the seventies.

It was Monet's intention to use his "bad sketches" for a larger work, but (perhaps because of parental opposition and a lack of funds) the project was interrupted. It was Renoir who, in the great *Luncheon of the Boating Party* (Phillips Collection, Washington, D. C.), was to raise this surburban genre to its height. Monet was less gregarious, and his art was to follow a path less humanistic, but closer to nature.

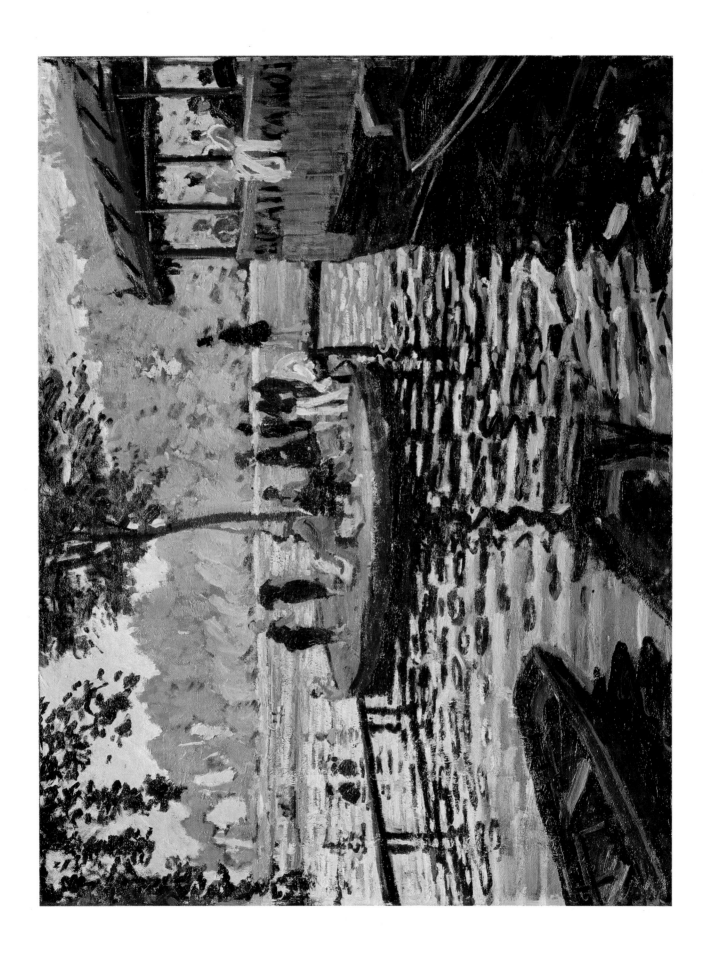

Painted in 1870

ON THE BEACH, TROUVILLE

(LA PLAGE DE TROUVILLE)

Oil on canvas, 15 × 18"

Reproduced by courtesy of the Trustees,

The National Gallery, London

Perhaps unjustly, Eugène Boudin's reputation is at present based almost entirely on his studies of vacationers gathered at the bathing resorts of Deauville and Trouville (figure 20). During the summer of 1870 he was joined there by Camille and Claude Monet, who had married in June. Though war was declared in July, they talked, sat on the beach, drew, and painted until September. Many years later, in a letter to Monet, Boudin nostalgically recalled their last extended period of work together:

> *I can still see you with that poor Camille at the Hôtel de Tivoli. I have even preserved from that time a drawing that represents you on the beach. Three women are there in white, still young. Death has taken two, my poor Mary Ann and your Camille. . . . Little Jean plays in the sand and his papa is seated on the ground, a sketchbook in his hand—and does not work. It is a memory of that time that I have always preserved piously.*

Many of the subjects painted by Monet that summer—of which the *Beach at Trouville* (figure 19) is typical—resemble those of Boudin; but this vital sketch is like an enlarged detail, at once more intimate, more powerful in impact, and more spontaneous. In fact, grains of sand are still embedded in the pigment! Monet's bold attack may have been encouraged by Courbet, for even Boudin had been impelled to broaden his small-scale manner after seeing Courbet's rough strokes, often applied with a palette knife. Monet knew this was not his tool, though he used it briefly about 1865, just after he had met Courbet. Manet also painted some seashore figure subjects, and it is interesting to note how closely the rich tones of the head and flowered hat of the woman at the left in this painting approach similar passages in Manet's canvases of the sixties, though Monet's handling is more audacious. He is entirely untroubled by the flattening effect of his thick strokes on the hollow domes of parasols and the bulk of heads, or by the refusal of the white impasto on the skirt either to dissolve in light or explain form. Yet he has not forgotten to frame and organize effectively: the relationship between the inward-looking profile, the chair, and the shadowed right-hand figure is almost studied; and the entire composition is unified by the parallel horizontals that begin at the left, flatten "Camille's" face, and continue toward the dark parasol and clar-points at the far right.

62

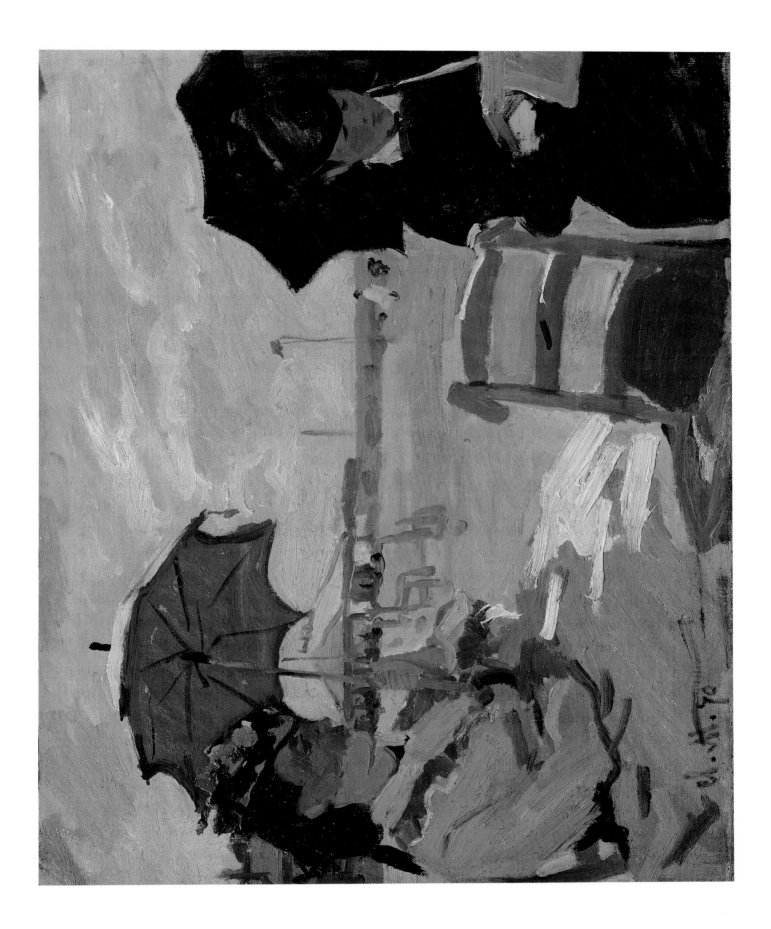

Painted in 1871

WESTMINSTER BRIDGE

(a.k.a. THE THAMES BELOW WESTMINSTER)

Oil on canvas, 18½ × 28½"

Reproduced by courtesy of the Trustees,

The National Gallery, London

(Bequeathed by Lord Astor of Hever)

This evocative riverscape is one of the finest records of Monet's wartime stay in England. It was painted on the Embankment, close to the site of the Thames canvases of 1899-1904 (figures 51, 52, and page 121), and it heralds their qualities of mystery, simplification, and order. In sharp contrast to the Dutch canvases of the same year, its color scheme is one of atmospheric unity rather than opposition. Every square inch of surface is permeated by the tremulous mist—at once gold, pink, green, and violet—that transforms the stone of the distant buildings into delicate patterns of warm or cool blue and the bridge into a soft, rhythmic extension of the horizontals of the wharf. Save for one crimson accent, the tugs are silhouettes: they float on a field that, were it not for the crisply stroked waves, would be a continuation of the sky. The asymmetrical composition is marked by striking innovations: Notice how the rapid recession of the shore and trees is suddenly halted by the contradictory diagonals floating on the water, and how the composition is ordered by the meticulously spaced horizontals and verticals of the wharf and ladder.

The Franco-Prussian War was to have a crucial bearing on the fortunes of both Monet and his friends. As a Republican, he had little taste for defending the Empire, so, leaving his wife and child in France, he fled to London in September 1870. Here he was introduced by Daubigny to Paul Durand-Ruel, who had opened a gallery at 168 New Bond Street. Modern art history would have followed quite different paths without this far-sighted dealer's sponsorship, first of Monet and Pissarro (also a refugee in London), and then of Renoir, Degas, Sisley, and other Impressionist painters. When they visited the London museums, Monet and Pissarro found certain of their innovations confirmed in the paintings of Constable and Turner (whose Romanticism could be cited as a precedent for the golden light of the present canvas), though it should be noted that Constable's early sketches were not to be seen, that both Englishmen had been influential in France long before 1870, that Monet, Renoir, and even Pissarro would later express disappointment with Turner, and that few traces of English influence can be found in their work. If Monet had a precedent for such a tonal and geometric composition, it was in Japanese prints and / or the art of Whistler, for which he was later to express admiration.

64

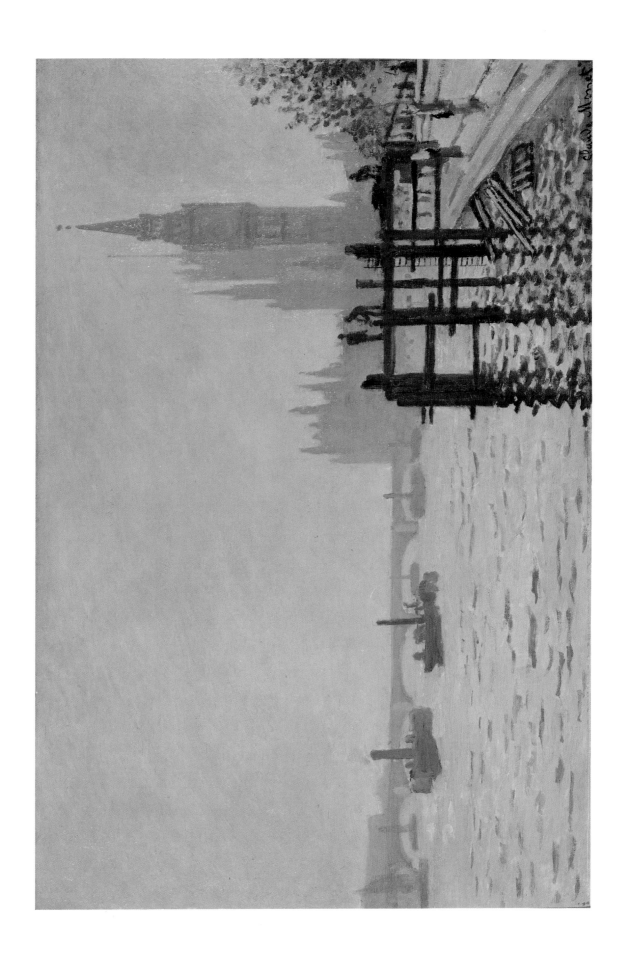

Painted in 1872

IMPRESSION

Oil on canvas, 19⅝ × 25½"

Musée Marmottan, Paris

(Collection Donop de Monchy)

An "impression" has been defined as a "neural and immediate psychical effect of sensory stimulus." By this token, it is easy to imagine oneself in Monet's position here in the harbor of Le Havre, bobbing on the waves in a small boat—a lone observer, engrossed in a unique and transitory moment that will never be repeated.

Monet was one of the organizers of the exhibition of the Société Anonyme des Artistes Peintres, Sculpteurs, Graveurs, Etc., which took place in the former studio of the photographer Nadar, 35 Boulevard des Capucines, April 15-May 15, 1874. Of Monet's nine entries, only the five oils were titled. They cannot be positively identified, but one possible list would include *Wild Poppies* (page 71), *Le Havre: Fishing Boats Leaving the Harbor* (figure 4), *Boulevard des Capucines* (page 69), *The Luncheon* (page 59), and this painting, exhibited as *Impression: Sunrise*. The augmented title may be inaccurate, for the sun is above the horizon—though the blue and orange haze does call to mind the strange moment when night meets day.

The *Impression* immediately drew the critical abuse of M. Louis Leroy, critic of the journal *Le Charivari*, who concluded a mock conversation (purporting to determine the painting's subject) with biting sarcasm: "What freedom, what ease of workmanship! Wallpaper in its embryonic state is more finished than *that* marine." The sharpness of distaste often isolates qualities obscured by adulation. Flatness and freedom of handling are hallmarks of Monet's finest work. Unintentionally, Leroy imprinted the unassuming title of this painting on the art of over half a century, for his review appeared under the headline "Exhibition of the Impressionists," and the term was rapidly accepted. The warmest sympathy could not have singled out a more appropriate prototype to christen the new movement. Yet, seen in retrospect, how few of the characteristics that have been associated with Impressionism—systematic division of spectral pigments, optical mixture, and concentrated sunlight, among others—it demonstrates! Its spirit is poetic rather than "scientific": one is instantly placed in communion with the most intangible and fleeting aspects of nature. The sprawling fleet of merchant ships, indistinguishable from harbor installations, is lost in a mist at once shadow and light, cold and warm. More ephemeral than the lapping tide, the quiet boatmen in the foreground are weightless shadows. Applied in the thinnest of washes, the blues and oranges are muted by the graying effect that complementaries have on each other; only the disk of the sun and its pigmented reflection, whose sharp strokes move down the canvas like an Oriental colophon, are solid.

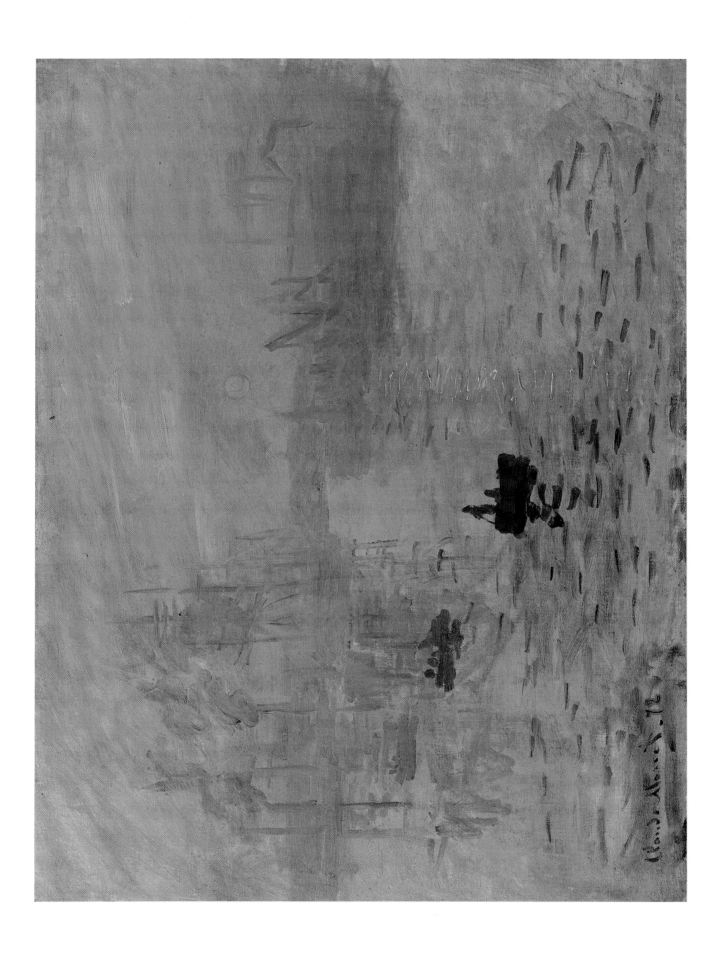

Painted in 1873

BOULEVARD DES CAPUCINES

Oil on canvas, 31½ × 23⅝"

Nelson Gallery–Atkins Museum, Kansas City

(Acquired through the Kenneth A. and

Helen F. Spencer Foundation Acquisitions Fund)

Monet was a close friend of the photographer known as Nadar, from whose studio he painted two views of the Boulevard des Capucines looking toward the Place de l'Opéra. At the right edge of the painting we can barely discern silk-hatted figures who stand on a balcony located across the little Rue Danou which meets the Boulevard opposite Nadar's corner window. Like Monet, these people observe a vista of strolling figures and fiacres coming and going in the street below. The first Impressionist exhibition was held in Nadar's studio, and Monet appropriately included among his entries one of the views of the Boulevard. To M. Leroy, the critic of *Le Charivari* (who put his observations in the form of a conversation with a hypothetical M. Vincent), the *Boulevard des Capucines* was every bit as ludicrous as the *Impression*:

"Ah-ha!" he sneered in Mephistophelian manner. "Is that brilliant enough, now! There's impression, or I don't know what it means. Only be so good as to tell me what those innumerable black tongue-lickings in the lower part of the picture represent?"

"Why, those are people walking along," I replied.

"Then do I look like that when I'm walking along the Boulevard des Capucines? Blood and thunder! So you're making fun of me at last?"

"I assure you, M. Vincent...."

"But those spots were obtained by the same method as that used to imitate marble: a bit here, a bit there, slapdash, any old way. It's unheard-of, appalling! I'll get a stroke from it, for sure."

Critic Leroy's diatribe suggests the objections that are so often raised, in our time, to abstract and expressionist painting; yet how true to visual experience, and how effervescent, the same picture appears now! On the basis of the art he knew, "M. Vincent" could not accept what his sight would have confirmed had he looked out the window of the exhibition room at the people walking below, who indeed resembled those "black tongue-lickings." Accustomed to representations in which distant, and even moving, objects were defined with conceptual exactness of detail, he could not understand that such exactness is supplied by memory or imagination rather than by momentary perception. He did not realize that the odd technique that puzzled him was a means of capturing in a static medium the effect of movement, or that the tonal accuracy of Monet's transcription of the blue-violet atmosphere (so typical of Paris during the cool months) would later be verified by color photography.

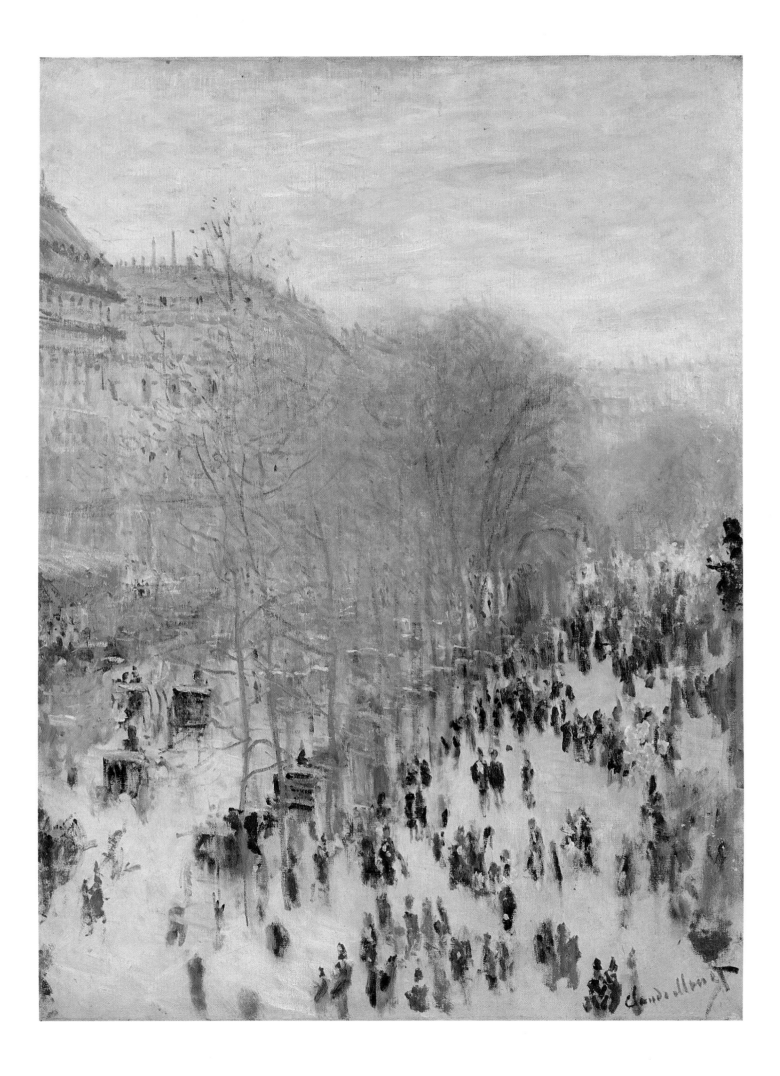

Painted in 1873

WILD POPPIES

Oil on canvas, 19⅝ × 25½"

The Louvre, Paris

Wild Poppies may have been shown at the first Impressionist exhibition. It is surely an "impression"—in its simplicity, in its flatness of tone, and, it should be said, in its lack of analytical broken color.

The short period from 1872 until 1875 was relatively tranquil for Monet and Camille, and if one can judge from the paintings, it was the happiest since the carefree days at Chailly. This is attested not only by sunny riverscapes but by affectionate studies of Camille relaxing, sewing, or enjoying the sun, and Jean (six years old in 1873) playing with his toys or, in this instance, gathering flowers with his mother. In 1874 both Manet and Renoir painted the Monet family, Camille seated in the grass with Jean, and Claude painting or working in his garden.

In its delicately brushed and thinly painted tones, *Wild Poppies* is different from many works of Monet's Argenteuil period. Similar studies of figures strolling in the fields and collecting flowers were painted by Renoir, but in these, the foreground blossoms beg to be plucked, and they invite the spectator to enter the scene. Monet's world, because of the patterned foreground, the lack of intimate detail, and the importance given to the sky, is less accessible. For Renoir, nature was an Eden without cold or rain, a soft background for human relaxation; but for Monet, man was but a part of nature. He once advised a painter that "every leaf on the tree is as important as the features of your model." Here the lilting rhythm and soft brushing of the figures is tender, but the enlarged scarlet patches that Monet's optical sensibility selected from the detail of the field are the keynotes of the work. Though their shapes are characteristic of the poppy, they are nevertheless all but abstract. As in the Brittany landscapes of Gauguin, the cumulative effect of these shapes is two-dimensional and decorative, even though their random placing and diminution in size lead backward, uniting the pair of figures in the background with the pair in the foreground. Unintentionally, perhaps, Monet has experienced and recorded the apparent enlargement of bright warm color areas when placed before a duller complementary background—a phenomenon that color theorists were studying systematically.

70

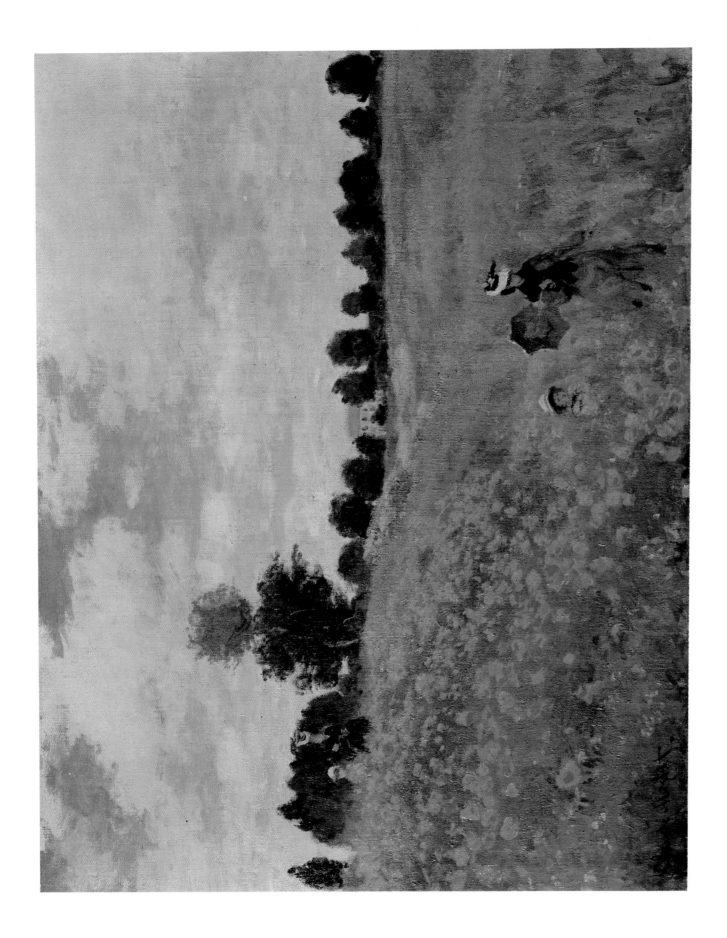

Painted in 1874

THE BRIDGE AT ARGENTEUIL

Oil on canvas, 23⅝ × 31½"

The Louvre, Paris

If Impressionism ever became a group style it was during the three years from 1873 to 1875; and if that period can be represented by a single motif, it is the Seine near Monet's home at Argenteuil. Ever since 1869, Renoir and Monet had continued to meet and paint works that were almost identical in style; at Argenteuil they were often joined by Sisley, Caillebotte, and, finally, in 1874, even by Manet. Given a feminine touch, river subjects were to become characteristic of Berthe Morisot as well.

The *Bridge at Argenteuil*, therefore, can be said to typify Impressionism at least as well as any other work. The scene has been recorded with amazing fidelity to casual vision. Over a flat underpainting, broken color is employed—but only where it can best translate a particular passage of light, movement, or surface texture. Kept within a narrow range of adjacent hues, it gives transparency to the soft shade of the bridge and the sun-flooded tower, and to the greens of the trees across the river, the effect of variously illuminated leaves. But the sky and the quiet water in the foreground are rendered in tones that are almost flat. The three sailboats are barely suggested, in loaded strokes, as a single pattern, for Monet was uninterested in bulk and mechanical detail. Yet each material, texture, and light effect provides its corresponding brush rhythm.

On what evidence can the idea of the "accidental" composition of Impressionism have been based? The marvelous tranquillity of this design is almost classic. Unlike Poussin, Monet would never have invented elements or arranged them according to a traditional scheme; nor would he have rearranged and radically re-formed what lay before him while he was painting, as did Cézanne or Van Gogh. Nevertheless, he carefully controlled recessional lines and scrupulously adjusted his frame to the immovable elements given in the subject. In relation to these elements, the boats could be shifted at will. Of the hulls, the building and its reflection, the tilting verticals of the masts, the furled sail that cuts the frame at the left, and the ruled triangles of the rigging he has made an airy geometric construction that delicately orders the entire design. The landscapes of Seurat emphasize what Monet had discovered intuitively: qualities we call "classic" in the scenes he saw every day.

72

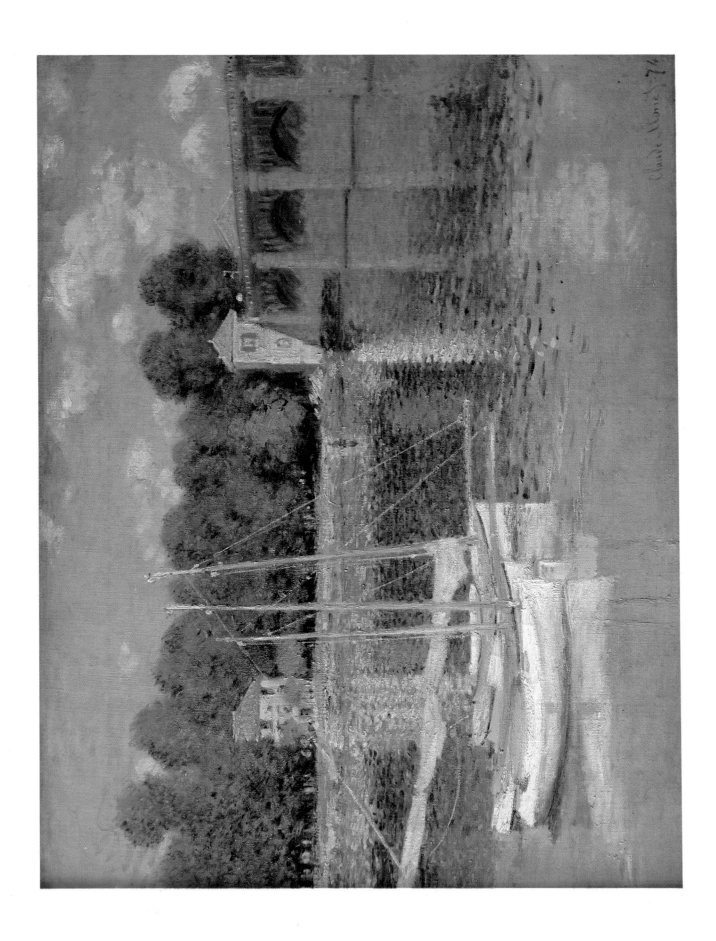

Painted about 1875

SNOW AT ARGENTEUIL

Oil on canvas, 22½ × 29"

Courtesy of the Museum of Fine Arts, Boston

(Bequest of Anna Perkins Rogers)

The often-repeated theory that Monet was primarily interested in bright sunlight, and that in painting snow his chief concern was for pure blue shadows, is a gross oversimplification of his motivation. Except for night scenes (which could not be painted impressionistically), Monet pursued all phenomena of atmosphere, light, and weather—from dawn to dusk and from spring to winter—with equal devotion. Rain was an unpredictable interference with his plans, and it frustrated and enraged him; but even cloudbursts did not always stop his work. Late in the seventies he painted mist so thick that one unsatisfied patron could see nothing but blank canvas; and, in 1901, he complained to Durand-Ruel that the weather was "a bit too beautiful," hoping for "rain and even cold" in order to get back to work.

Snow at Argenteuil probably belongs to the magnificent group of winter scenes which includes *Train in the Snow* (figure 32). Protected from a gentle snowfall by their umbrellas, several villagers trudge slowly down the peaceful street. In part, this tranquil mood derives from a scale of harmonious grays that, reacting on each other, take on casts of violet, green, blue, tan, or the less chromatic tones indicated by such terms as dove, pearl, slate, lead, or taupe. Four steps in value set the key: the receding walls, distant trees, and buildings; the snow-covered roofs; the heavy sky; and the broken foreground. Each of the largest snowflakes is represented by a single off-white touch, while smaller ones fuse with the damp haze to become a transparent gray veil over the scene. In addition to foliage, pebbles, grass, and other fragmented nature forms, falling snow thus offered Monet another clue to the representation of atmospheric density. The textured field at the right is especially rich, built up by an accumulation of the muddy blue, brown, and violet tones of twigs, earth, and dead leaves, the varied whites of new or soiled snow, and (though here they cannot be differentiated) the quietly falling flakes.

74

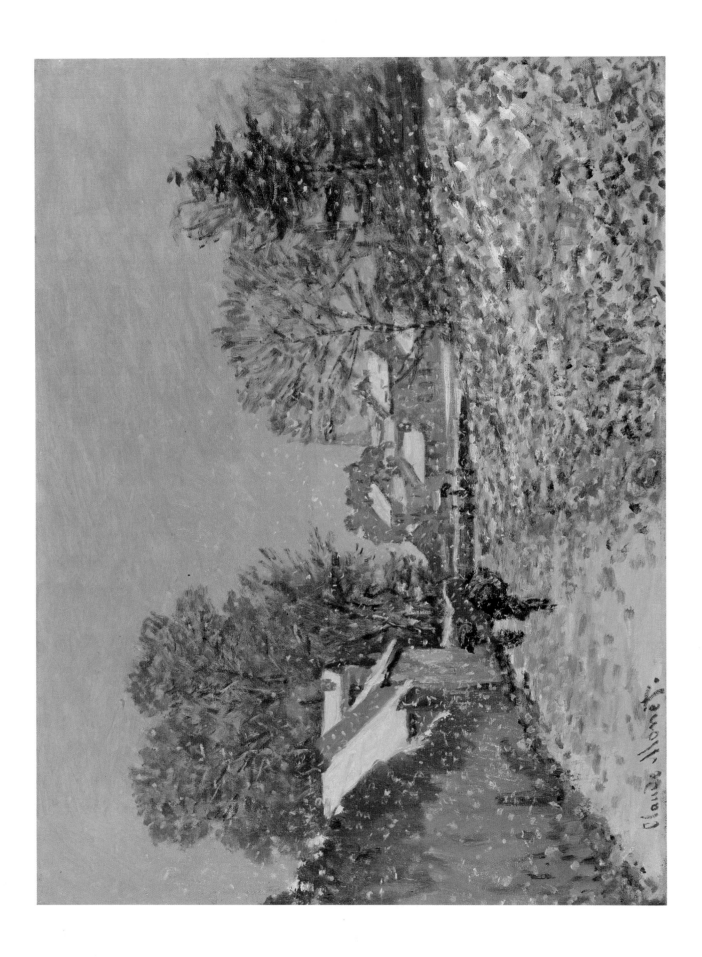

Painted in 1875

MADAME MONET AND CHILD

(a.k.a. CAMILLE MONET AND A CHILD IN A GARDEN)

Oil on canvas, 22 × 25¾″

Courtesy of the Museum of Fine Arts, Boston

(Anonymous gift, 1976)

Large figure groups like the *Picnic* and *Women in the Garden* were expensive to paint and all but impossible to execute in the open; and except for the *Camille* none of Monet's audacious early figure paintings found their way into the Salons for which they were intended. Perhaps for these reasons, and also because of his discovery of the Seine and the new pattern of his life at Argenteuil, the attempt to produce monumental outdoor compositions was abandoned after *Women in the Garden*. The Argenteuil figure studies are smaller in size and more intimate in mood. Monet was intensely domestic, and adored flowers; and from 1872 until Camille's illness became serious, the home and garden were recurrent themes in his art.

Madame Monet and Child is one of Monet's tenderest portraits. Sequestered by the wall of roses, the two figures seem oblivious of everything but their work and play. Because of its decorative pattern, painterliness, and contrast of warm and cool color, the floral frieze advances to almost surround the figure of Camille as she sews; and against the shadow below, the congruent triangles of the skirt and the tiny figure on the ground become related geometric units. The technique of broken color has now been fully developed, for the major part of the canvas surface is worked in trembling flecks of pigment; but qualities other than light and the vibration of color are also expressed in brush movements. By careful strokes of a deep tone, Mme. Monet's hair is dexterously arranged, then softly blended at the forehead and the nape of the neck; her delicate features are touched in with the lightness of Watteau; and curving contours give fullness to the throat and collar. The hands are barely suggested—but with a tactile sensibility identical to that of the fingers as she thoughtfully pierces the fabric with her needle. The white cloth elicits a looser treatment, and around the shoulders light contour lines give a soft texture to the dress while they define the body underneath. The "intimism" of Vuillard owes something to this period of Monet's art; while painting the patterned enclosing walls of his mother's apartment and the gentle hands of her seamstresses, Vuillard may have recalled the qualities of works like this one.

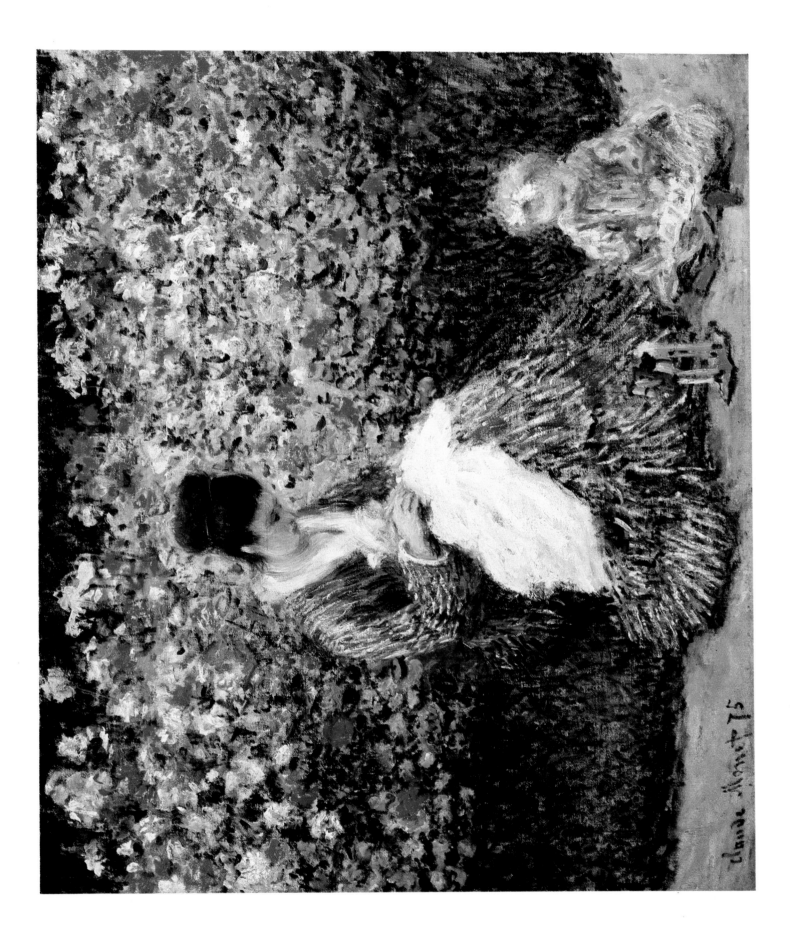

Painted in 1876

MADAME MONET IN JAPANESE COSTUME

(LA JAPONAISE)

Oil on canvas, 91 × 56"

Courtesy of the Museum of Fine Arts, Boston

Except for being the most conspicuous document of his love of Japanese objects
and decorative arrangements, *La Japonaise* is a total break with the principles that
usually govern Monet's art. Characteristically, he chose a "real" subject and altered
it only to uncover its essence. Here the motif is entirely contrived. The floor is
covered with patterned matting, and the wall is ornamented with fans in a bizarre
scheme that led one critic of the second (1876) Impressionist exhibition to remark
that, by "an incomprehensible miracle of equilibrium" they were hanging in
mid-air, and another to suggest that the blond Parisienne was a juggler. Indoors
or outdoors, Monet by 1876 was a painter of atmosphere, but the space of *La
Japonaise* is airless; and (save for the face in the style of Renoir) the handling is
devoid of Impressionist qualities. Sweetened and generalized, the head is that of
Camille. Though probably derived from a Japanese print, her affected pose and
coy gesture with a tricolored fan—in which the critic of *L'Evénement* saw a note
of patriotism—bear little resemblance to anything Oriental. The theatrical robe was
most likely of silk; yet, as the *Constitutionnel* noticed, it resembles heavy homespun.
Its flamboyantly embroidered and magnificently painted samurai (like the bear's
head in Whistler's *White Girl* of 1862) seems to project in actual relief. Black as
the night in his fury, the monster dominates the composition and, rising in a tight
spiral, rescues it from saccharine mediocrity.

It is plain that Monet—borrowing shamelessly from Renoir, Whistler, and
Manet—set out to startle the public by what Charles Bigot called "a pistol shot."
It was a complete success, and was sold for two thousand francs. When, in 1918,
a guest informed Monet that the "marvel" had been resold for 150,000 francs, he
replied that the buyer had acquired "*une saleté* [trash]." Pausing to hear an ex-
clamation of incredulity, he explained, "But yes, it was trash in being nothing but
a caprice. I had exhibited the Woman in Green [*Camille*, figure 8] at the Salon with
very great success, and I was advised to make a sort of pendant for it. They tempted
me by showing me a marvelous robe on which certain gold embroideries were
several centimeters thick." Monet further informed his visitors that Camille had
been the model, but that he had given her a blond wig. Questioned on whether
his shocking remarks were sincere, he answered, "Absolutely," adding—and the
correspondent notes a "certain artist's pride" in his voice—"look at those fabrics!"

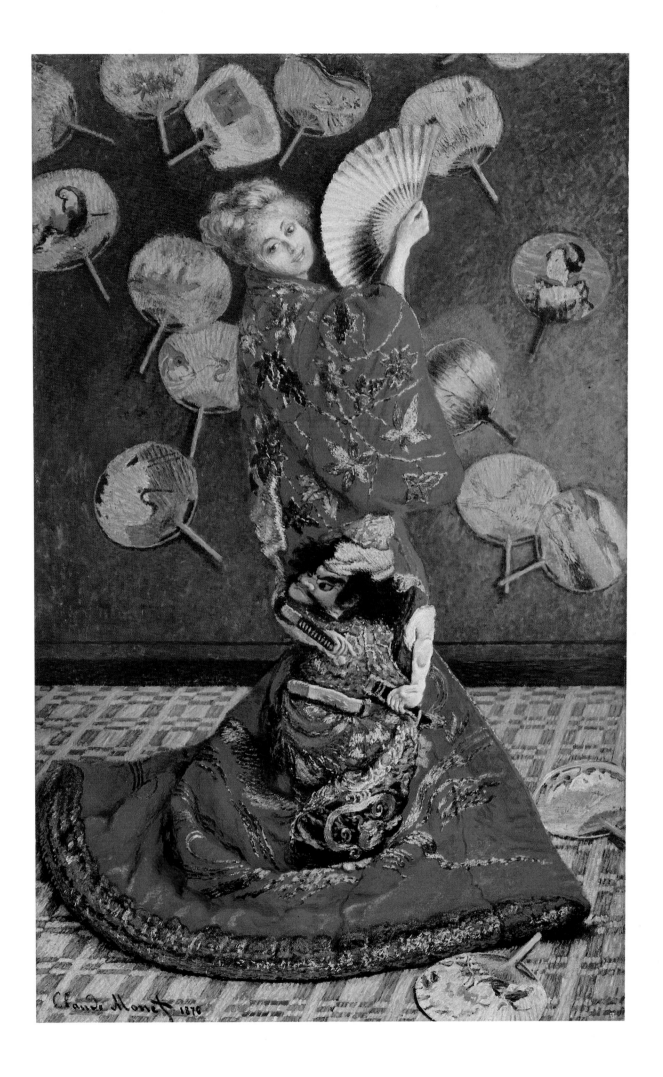

Painted in 1877

GARE SAINT-LAZARE

Oil on canvas, 32½ × 39¾"

Courtesy of the Fogg Art Museum, Harvard University, Cambridge

(The Maurice Wertheim Collection)

Among his submissions to the third Impressionist exhibition, held in April 1877, Monet included at least seven canvases painted inside or near the Gare Saint-Lazare. Though Monet, Pissarro, and Sisley had painted the railroad as a feature of landscape, the first precedent for so unorthodox a motif was Turner's *Rain, Steam and Speed* of 1844, which represents the Great Western Railway thundering over a bridge through driving rain and mist. Monet's subject, however, was closer to everyday life. To the Impressionists who had often met in the Batignolles Quarter during the sixties, the trains approaching along the edge of the Quarter were a familiar sight; and, as suburban painters, they passed through the station repeatedly. Near the station, six thoroughfares, named after European cities, converge above the tracks on a viaduct also painted by Monet: the Pont de l'Europe. During 1873 Manet had painted his favorite model, Victorine, before a grill overlooking the same tracks, but in that painting the passage of the train below is indicated only by a cloud of smoke.

In 1876, the year Monet began the Saint-Lazare series, Emile Blémont had observed in *Le Rappel* that Monet was making "orgies of the rainbow" just as Turner had made "orgies of blue." What his series of the railway station meant to the Impressionist group (and perhaps to Monet himself) was suggested in a short-lived journal, *L'Impressionniste*, edited by Georges Rivière and devoted to combatting the hostility of the press toward the new group. Stimulated by one of Monet's canvases, Rivière likens the locomotive to an "impatient and fiery beast, animated rather than fatigued by the journey it has just completed." It "shakes its mane of smoke, which strikes against the glass-covered roof of the great hall." For him, the series calls up the cries of the railroad workers, the screams of whistles, the clatter of arrivals and departures, the trembling of the terrain under great wheels, and the drama of merging sun, soot, smoke, and steam.

It must have been this final shifting effect that most attracted Monet. In the dusty blue shadow, penetrated by the sun's rays from above, the impalpable puffs and darker clouds—opaque, dissolving to transparency, or shredded into bits—are suspended before the rigid glass, metal, and masonry. Viewed against the iridescent backdrop of the Pont de l'Europe and the buildings and sky beyond, they become almost substantial. Before this spectacle, and the delicate films of colored shadow that fell on the mechanical forms, Monet may well have been seized, as was Rivière, by "the same emotion as before nature."

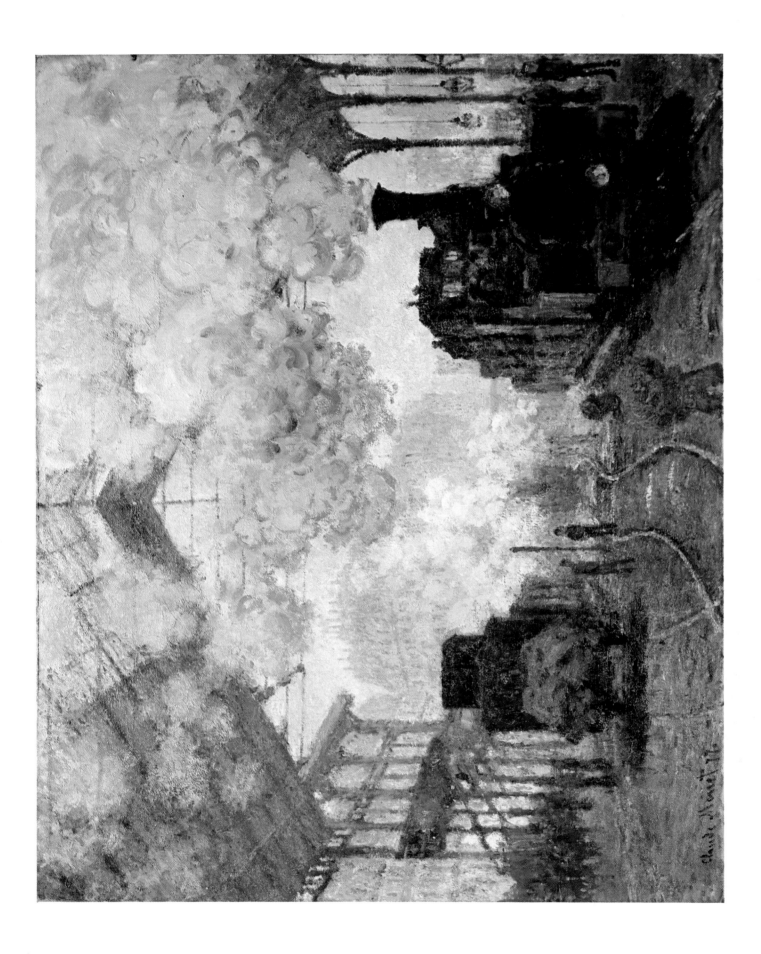

Painted in 1878

RUE MONTORGUEIL DECKED OUT WITH FLAGS

Oil on canvas, 24¼ × 13"

Musée des Beaux-Arts, Rouen

For part of the year of the Exposition Universelle, Monet lived in Paris, at 26 Rue d'Edimbourg, where his second son, Michel, was born in March. The gala events of June 28th-30th were climaxed by the first Fête Nationale to be held since the Franco-Prussian War and the Commune. From the Bois de Boulogne to Montmartre, Paris was alive with festival decorations that provided subjects for two works by Monet and two, both representing the flag-draped Rue Mosnier (now Rue de Berne), by Manet. "I liked flags very much," Monet reminisced in 1920. "At the first Fête Nationale, of June 30th, I was walking along Rue Montorgueil with my painting equipment. The street was decked out with flags, but swarming with people. I spied a balcony, mounted the stairs and asked permission to paint. It was granted. . . . Ah, those were good times, though life was not always easy. . . ."

How vividly Monet's account illustrates the directness and spontaneity which keyed his art to life, and how effectively he has transferred to canvas his excitement and that of the scene! Impressionism was an art of movement as well as light and color, and the demands of the moment often enforced a new technique. What are the visual sensations experienced in a milling festival throng? Do they not converge in a pulsating confusion—a dynamic interplay in which individual forms and identities tend to be drowned? In the interlacing sun and shadow, the windows, awnings, balconies, sidewalk stands, passing figures, and flying flags fill both the street and the air above. Empty volume becomes tangible, and solid masses insubstantial. Very differently from a camera image—which would freeze such a scene in a thousand details that no participant could experience—Monet's lightning brush has improvised its calligraphic equivalent. It is only with difficulty that VIVE LA FRANCE can be deciphered on the banner that spans the street.

Both the subject and treatment of *Rue Montorgueil* project toward the future—to Van Gogh's *Fourteenth of July*, to the subjective street scenes of the Fauves and the Futurists, and to paintings of New York by John Marin and Mark Tobey. There are few works that illustrate better the dynamism of Impressionism.

82

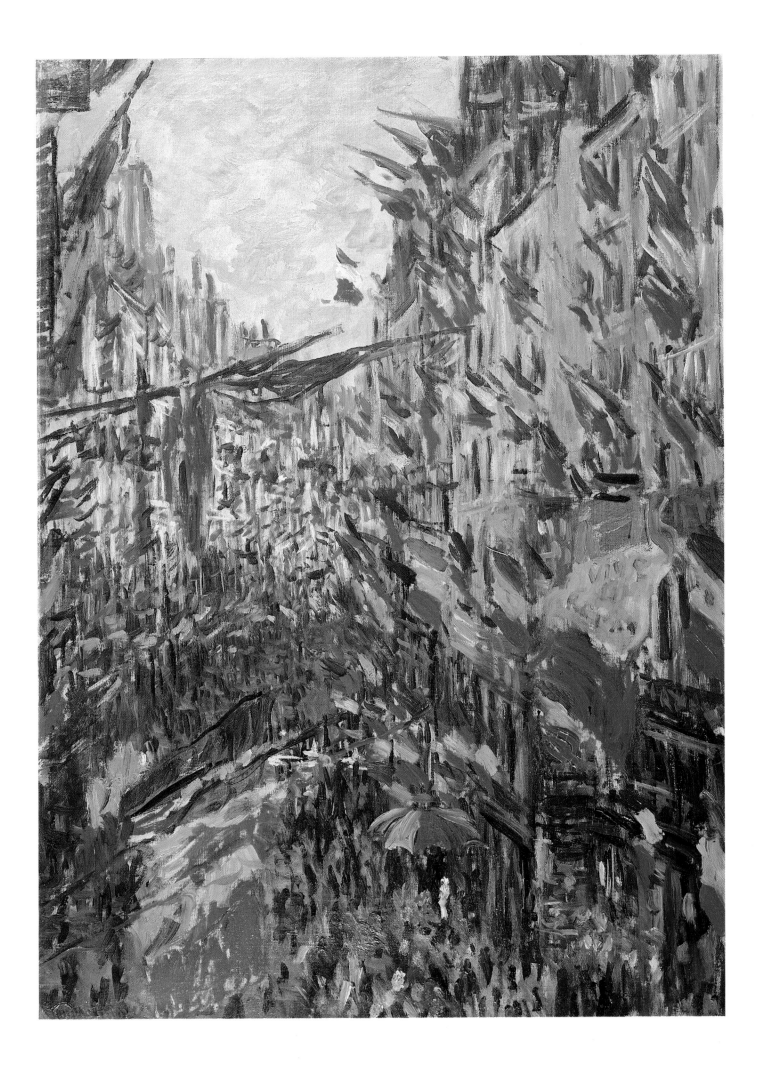

Painted about 1878

SNOW EFFECT AT VÉTHEUIL

Oil on canvas, 21½ × 27½"

The Louvre, Paris

Early in 1878, after two unsettled and difficult years, Monet left Argenteuil for Vétheuil, which was also on the Seine but farther from Paris. The pictures of this period have been given less attention than those of Argenteuil, yet his productivity at the new site was immense, and splendid in quality. Compared with the suburban cheerfulness of the earlier riverscapes, however, those of 1878-81 are quiet, deserted, and often in a minor mode. The house Monet occupied late that first winter still stands, one of three built in a row at the edge of the village, and directly on the road that parallels the Seine (figure 38). Across the road were a terrace, a garden, and steps leading downward to the river bank where the *bateau atelier* was moored. Though the vista from this point lacked the pleasure boats, bridges, and barges that had served Monet as motifs at Argenteuil, the Seine here is, if anything, even more paintable. At that time tiny islands dotted the channel; and just upstream from the village the Ile Saint-Martin, its rich vegetation accented by tall poplars, stretches for almost two miles. Across the river the quaint village of Lavacourt offered a background for Monet's studies from the bank below his home; and if he chose to paint from the opposite shore, from an island, or from the *bateau atelier*, there were fine hills that rose beyond the river, and the silhouette of Vétheuil was capped by the charming village church, which he also painted at close range.

Snow Effect at Vétheuil must be a view either from the floating studio or an islet. The river seems to approach the village more closely than it does today, perhaps because the spring flood (which was to be Monet's chief subject in 1880 and 1881) had already begun. Among the riverscapes, which range from tiny sketches to ambitious compositions, this is one of the smaller works; but for those who know Monet's work well it is a favorite. The broken technique mastered at Argenteuil is used here almost unintentionally, like handwriting, to record the cold silence of a rural winter. No attempt is made (as in the Haystacks of 1891) to extract each nuance of color from the motif. The effect is subdued, and, except for the warm darks of the rapidly noted trees, the blue-jacketed figure, an accent or two of earth red, and shadowed detail, it is almost monochromatic. Characteristic of the Vétheuil period is the application of pigment: played against, or over, solid areas of tone, the quick touches are wonderfully crisp.

84

Painted in 1880

THE BREAK-UP OF THE ICE

Oil on canvas, 26¾ × 35½"

Calouste Gulbenkian Foundation, Lisbon

The illness and death of Camille mark the end not only of a great period in Monet's art but of his close association with the Impressionist group. When asked, in 1880 (on the occasion of his exhibition in the editorial offices of *La vie moderne*), whether he had abandoned the Impressionist group he answered, "Not at all. I am and wish always to remain an Impressionist . . . but I see the men and women who are my confreres only rarely. The little church has become a banal school which opens its doors to the first dauber who comes." At Vétheuil, Mme. Hoschedé and her children had cared for Camille until her death in September 1879, and remained with Monet afterward. Despite the tragic events that preceded it, 1880 was an especially productive year. It was marked by an impressive series of still-life paintings and by many scenes of the Seine; but here, farther from Paris than Argenteuil, no gay suburban life appears. There are some sunny, and even lyrical, works, but 1880 and 1881 are dominated by a somber series representing the river in flood and choked with ice. Few landscapes have concentrated so despondent a mood of cold and loneliness. "His blocks of ice under a reddish sky are of an intense melancholy," J.-K. Huysmans writes in 1882. In the entire group the only signs of human life are the distant houses and, in certain versions, small boats crushed in the jam. In others a sullen red sun is setting, about to disappear forever, it would seem, behind a world devoid of life.

The Break-Up of the Ice is one of the finest of the group. The brackish water was first underpainted, and on this surface, in sudden movements suggesting those of the floe itself, Monet has transferred the slabs to canvas in thick, sharp-edged strokes of frigid blues, ice greens, and muted whites. On the inundated island one isolated tree trunk stands rigidly perpendicular to the water level; the others, drawn in strokes of unretouched freshness, are twisted or bent by the flood and the crushing blocks. Across the river the houses of Lavacourt huddle desolately together under a leaden sky.

Painted in 1881

SUNFLOWERS

Oil on canvas, 39¾ × 32"

The Metropolitan Museum of Art, New York

(Bequest of Mrs. H. O. Havemeyer, 1929.

The H. O. Havemeyer Collection)

Unlike Cézanne, for whom the immobility of objects offered an opportunity for extended observation and meditation, still life was a secondary genre for Monet. He was an outdoor man, attracted by momentary and fugitive phenomena—that is, by *weather*. But there were days on which even so rugged a hunter as Monet could not venture out, and there were periods of discouragement over such an unpredictable quarry. Monet's working plans, and therefore his disposition, were always subject to nature's whims, and still-life painting was a means of avoiding enforced idleness.

Monet's deepest concentration on still life covers the period from 1880 to 1882, following the death of Camille. There are opulent studies of pheasants and other small game, a series representing fruits, and flower studies. Of the last group, *Sunflowers* is the finest. Although expressed differently, it continues the new emotionality displayed in the paintings of floating ice. In landscape this tendency was to increase, stopping just short of Expressionism in 1886; but in no still life was Monet to venture further in that direction than in the *Sunflowers*. Seen beside his earliest still lifes, which are so conscientiously realistic, or beside *Apples and Grapes* (figure 34), which is a play between tactile and perceptual reality, this is a luxuriant and highly charged intensification of nature. By means of heavy, intertwining strokes of rich pigment, the great blossoms are made to glow symbolically before their complementary background, while the leaves gesture like tongues of flame. Together, they generate a power that has its origin as much in the artist's emotion and the process of painting as in the motif; but, because of the masterful pattern of the golden ovals, the effect is as decorative as it is expressive. It was such qualities that were carried further by Van Gogh, seven years later, in his celebrated series of Sunflowers.

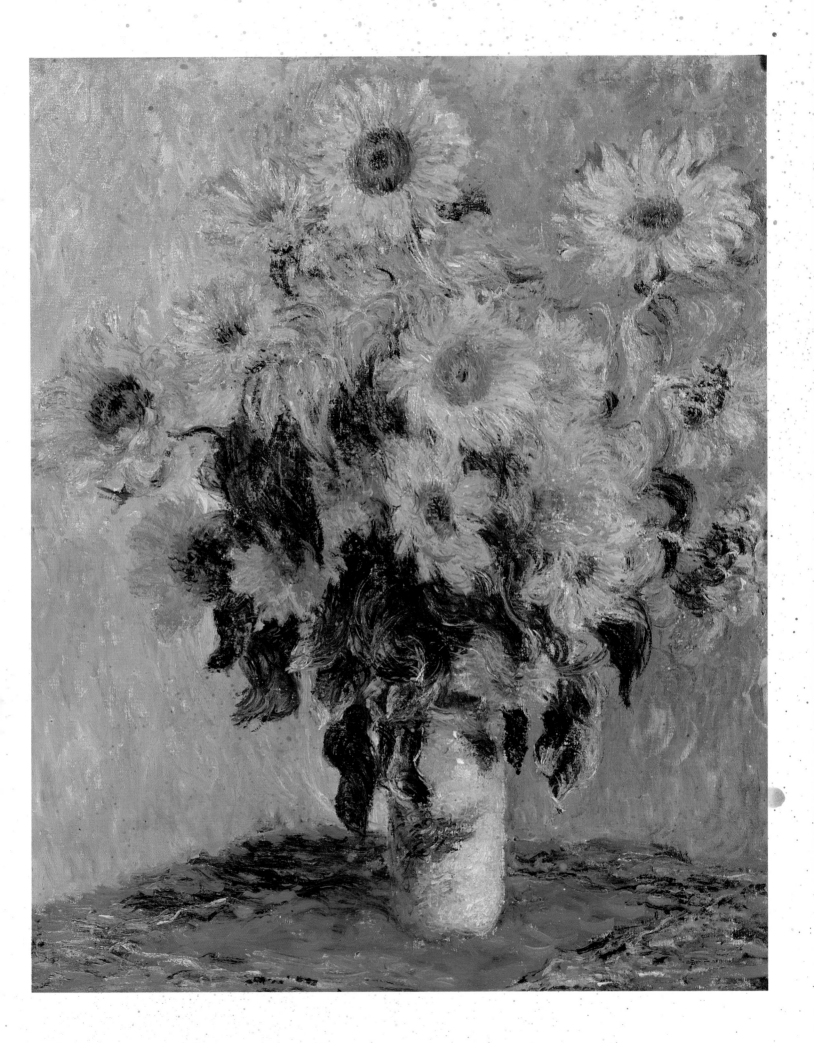

Painted in 1882

THE CLIFF WALK

Oil on canvas, 25¾ × 32"

The Art Institute of Chicago

(Mr. and Mrs. Lewis L. Coburn Memorial Collection)

The date, composition, and style of the *Cliff Walk*, and its close conformity to the terrain north of Pourville, suggest this region as its probable site. After a short stay in Dieppe in February 1882, Monet spent the greater part of the time until October at Pourville, where he painted two exceptional and almost expressionistic portraits, of the innkeeper Paul (figure 36) and his wife. His landscape subjects cover the five miles between Dieppe and Varengeville (figure 37) toward the south. Interrupted by cold, illness, rain, shrinking funds, and emergency visits to his temporary home at Poissy, he was nevertheless working "like a madman" in "splendid weather" early in April. After returning to Poissy in May, he was back in Pourville, with his own and his adopted family, by June. When the weather was dry he was happy, and "always outdoors." Occasional rainy days were passed painting still life or catching up on correspondence; but when a downpour continued day after day while the seasonal color began to change, funds dwindled, and canvases remained incomplete, he lost all courage, saw a future "too black," and destroyed unfinished work. "Doubt is taking possession of me," he writes to Durand-Ruel in September, "it seems that I am lost, that I can no longer do anything. I long to receive your remittance in order to close my trunks and suitcases and no longer to see my horrible canvases."

How often have wind, water, sky—the exultation and liberation of a summer day by the sea—been more joyously portrayed than in the *Cliff Walk*? Like other works of 1882, the canvas is divided into three areas. Played against a sharp horizon, the convoluted perimeter of the cliff follows repeated angular steps. The asymmetrical composition develops, as do other works of the Pourville group, by a series of triangles: these are emphasized in the shape and placing of the distant sails and echoed by the scudding clouds. Hue and texture, rather than value, serve to contrast the waving grasses with the sea. It is difficult to determine the plateau's exact angle in space, because Monet is more interested in its pattern, the tremolo of its color, and the quick surface rhythms of grass and wild flowers, just as he is in sunlight and the motion of wind and waves. How effectively the small figures that gaze seaward, their blowing garments, and the parasol humanize these intangible qualities of nature and give scale to the massive terrain!

Painted in 1883

THE CLIFF AT ETRETAT

(LA MANNEPORTE)

Oil on canvas, 25¾ × 32"

The Metropolitan Museum of Art, New York

(Bequest of William Church Osborn, 1951)

Among the eminent visitors inscribed in Etretat's *livre d'or* is the poet and novelist Guy de Maupassant. In an article of 1886 he recalls having observed Monet, who reminded him of a hunter when he was on a painting expedition. Monet was followed by children who carried "five or six canvases representing the same subject at different times of day and with different effects. He took them up and put them aside in turn, following the changes in the sky. And the painter, before his subject, lay in wait for the sun and shadows, capturing in a few brush strokes the ray that fell or the cloud that passed. . . . I have seen him thus seize a glittering shower of light on the white cliff and fix it in a flood of yellow tones that, strangely, rendered the surprising and fugitive effect of that unseizable and dazzling brilliance. On another occasion he took in his hands a downpour beating on the sea and dashed it on the canvas—and indeed it was the rain that he had thus painted. . . ."

Monet's motif for the *Cliff at Etretat* is the Manneporte, an immense rock arch that forms a bay just south of the lower cliff. The deserted beach on which he painted is even today almost inaccessible. Though the weather is fair for the Norman coast and the warm sun lights the inner surface of the mighty arch, clouds fill the soft blue sky and the high tide boils about the cliff. Except perhaps for Japanese prints there is little precedent for the cropped, asymmetrical composition. The radical fragmentary view gives the curving cliff face and shadowed sea a tremendous scale against the distant horizon, and they seem almost to lie in the same vertical foreground plane. Only variations of texture and color separate them: the surface of the arch woven into a fabric of stratification, blue shade, and pink reflected light; the sun-drenched underside in strokes which model the rocky surface more fully; and the sea in a froth of quick, deft curves of blues, and greens with cream-white highlights. Monet will continue this tendency to approach monumental, richly surfaced motifs more and more closely; it will be climaxed in the portrait of the rock (page 111), and the radically cropped façades of Rouen Cathedral and Venetian palaces.

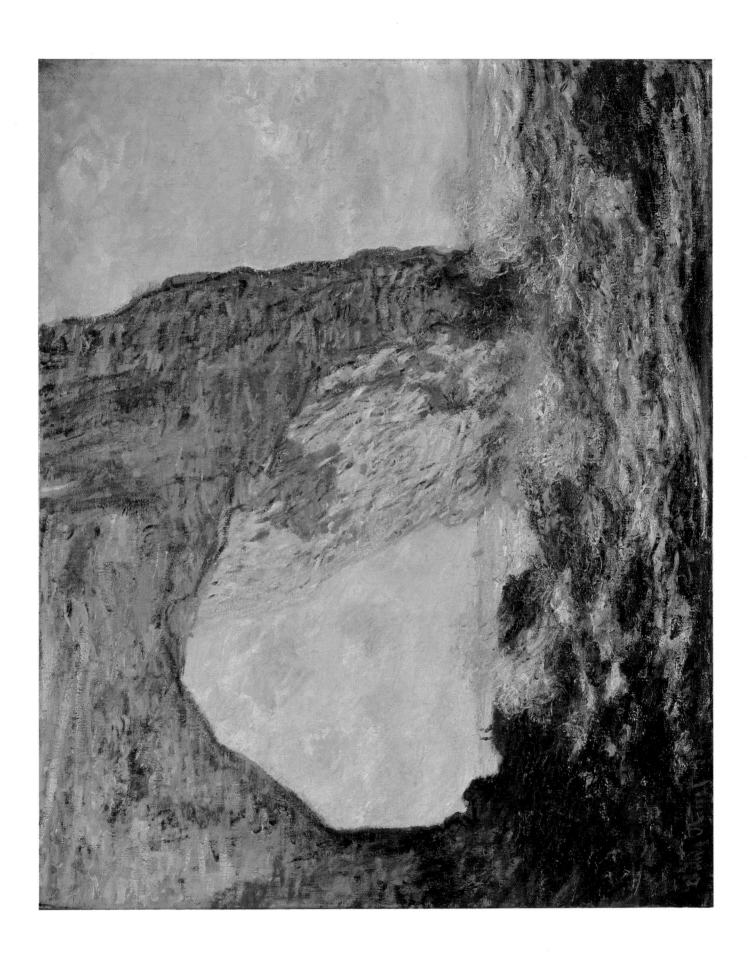

Painted in 1883

ROUGH SEA, ETRETAT

(LA PORTE D'AVAL)

Oil on canvas, 31⅞ × 39⅜"

Musée des Beaux-Arts, Lyon

The resort village of Etretat boasts, with some justice, "the most beautiful cliffs of France." As early as 1847 its little hotels and pensions welcomed devotees of ocean bathing, and by Monet's day it had long been a haunt of writers and painters. Among the best known of the latter group were Delacroix, Isabey (the master of Jongkind), Corot, Diaz, Boudin, and Matisse. The massive Lower Cliff, over two hundred feet high, had been painted ever since 1780, and was a favorite motif of Courbet, who in 1869 occupied a studio near it, which faced the sea. Though Monet had visited the site before, it was his new taste for dramatic subjects that brought him back in 1883, and from then until 1885 he returned each year. During the winter, Etretat was no longer a gay *station balnéaire*; the shore was deserted except for the fishermen, who stored their nets in unseaworthy hulls that had been roofed with thatch, known as *caloges*. When it stormed, the open sea crashed against the cliffs and ground together the rounded stones of the beach.

Monet's view of the Porte d'Aval may have been suggested by those of Courbet (figure 39). The interpretations of the Impressionist resemble those of the Realist in the precise delineation of the contours of the cliff and its dramatic flying buttress. Courbet, however, painted in an almost monochromatic sequence of "rock" tones, and with characteristic blackish shadows. In the interest of monolithic solidity, he all but ignored the coloristic horizontal stratification. For Monet these gray and violet stripes, like the rolling surf and the thatched roofs, were cues by which he laid in his brush rhythms, in strokes never smeared into a common tone or spread with a palette knife. Natural textures, both static and in motion, are brought forward and are enlarged. The striations, therefore, are fewer than in nature (figures 40 and 41). Both the vibration of the rock surface and the movement of the waves are intensified. Topographically, Courbet's beach and water surfaces are more accurate, for they lie horizontally; but in order to achieve his aims, Monet was forced to elevate his point of view, to tip the horizontal planes toward the vertical, and to raise the horizon: his brush needed space in which to move. Unlike the Realist, whose keynote was solidity, Monet's senses were stirred by the overwhelming strength of nature's forces, so that even rock is imbued with movement.

94

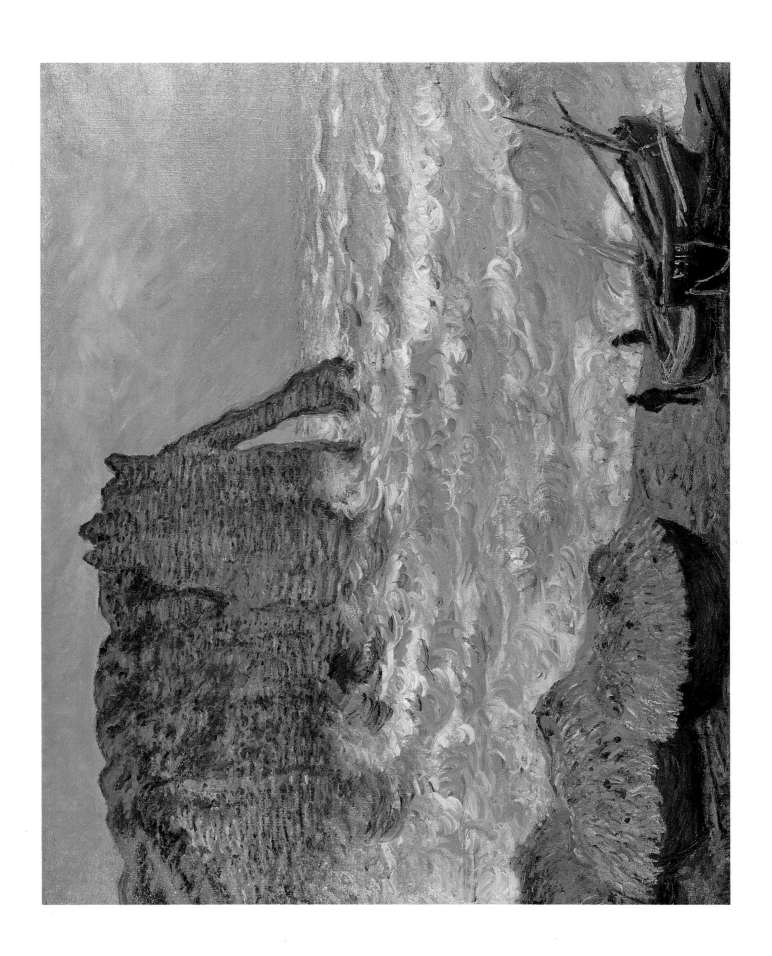

Painted in 1884

CAP MARTIN, NEAR MENTON

Oil on canvas, 26¾ × 33"

Courtesy of the Museum of Fine Arts, Boston

(Juliana Cheney Edwards Collection)

In December 1883, Monet accompanied Renoir (who had already painted the Mediterranean) on a two-week trip to the French and Italian Rivieras. They were delighted with what they saw, and planned to return to paint together. On January 12th, Monet wrote to Durand-Ruel for money so that he could leave immediately, and begged him to keep the trip secret. "I have always worked better in solitude and according to my own impressions," he explained, adding that he knew Renoir would have wanted to join him. From a pension in Bordighera, he writes later to say that he had communicated with Renoir and that he had "to be freer with my impressions," concluding characteristically, "it is always bad to work *à deux*."

Early in April, after painting a spectacular group of high-keyed canvases that forecast *Art Nouveau* as well as the emotional handling of Van Gogh, he passed several days painting the motifs that he and Renoir had discovered at Menton. One of the most dramatic of these is this view of the town, and the cloud-capped mountains that rise above it, seen from Cap Martin. Clouds and peaks merge in a rapid calligraphy of blue, white, and pink. The rough-surfaced rocks in the foreground take form in jabs of cream, bright shadow tones, and dark accents; between them orange strokes curve a path backward, toward the left, and through an irregular opening between the pines. Rococo in silhouette, they show Monet's concern with a new curvilinear drawing. The sea is a deep cobalt edged with green (the direct complement of the hot tones on the sun-flooded bank) and, opposing the ragged line of the Cape, the distant shore is a sharp horizontal that continues, less geometrically, as a shadow below the brushes, separating the lower section of the picture as a horizontal panel. Across this division, repeated diagonals unite the upper and lower fields.

A new bravura and brilliance of color is announced in this canvas. In his enthusiasm, Monet has pushed his high-keyed palette almost beyond the extremes of his subject, just as he has intensified and co-ordinated its geometry and rhythms. It is this barrier that was passed by Matisse and the Fauves after 1900, when they abandoned tone-for-tone conformity to nature for the joy of unhampered colorism.

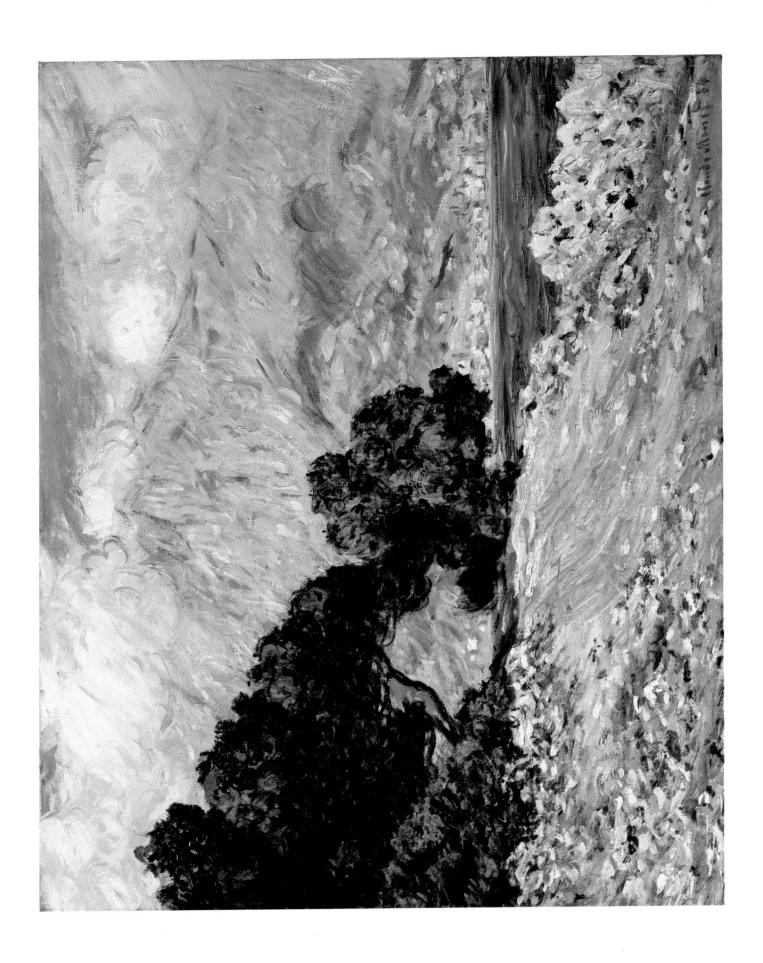

Painted in 1885

POPPY FIELD NEAR GIVERNY

Oil on canvas, 26¾ × 33"

Courtesy of the Museum of Fine Arts, Boston

(Juliana Cheney Edwards Collection)

Octave Mirbeau justly attributed to Monet the renewal of nineteenth-century painting. Two related peculiarities, above all others, fitted him for this historic role: first, his lack of interest in traditional modes of painting studio landscape in hypothetical color schemes and theoretical light and shade; second, the astounding visual sensitivity that made him see the world in its full chromatic richness. In an essay of 1916, "The Eye of Claude Monet," Remy de Gourmont observes, nevertheless, that he is not what is commonly called a "colorist," because "he makes nature gray when it is gray." Monet painted a colorful world because it existed, and because he had the naïveté, persistence, and genius to conform his thinking and his procedures to it. As his confreres recognized, he was endowed with a special gift; and through this gift Western painting was revolutionized. Without codifying his discoveries, Monet made full use of the oppositions of spectral color that he found in nature: blue and orange in the *Impression* (page 67), violet and yellow in painting shadow and sunlight, and green and red in *Wild Poppies* (page 71) and in this *Poppy Field near Giverny*.

It is interesting to compare these two paintings of a similar motif separated by more than a decade. In mood, the earlier is marked by a bucolic casualness. The horizon is low enough to show fleecy clouds, small detail is kept out of focus, the paint film is thin and sketchy, and edges are vague. Sown broadcast, the blossoms are liquid patches, each an independent unit against the faded green grass. In the later picture one is struck, first of all, by an unexpected scheme of one-point perspective—though it does not bring about recession (which is denied by the uniform pattern of red and green) but provides the foundation for a geometric and almost symmetrical design capped by the catenary curves of the hollow background. The sky area is small; and, in place of the relaxed handling of 1873, Monet has here examined the color pattern and rhythmic texture of each area with probing care and has transformed them into a clarified painterly equivalent. Yet, though the mood and manner are more analytical and art-concious, no fundamental change in principle has taken place. Like so many other works, this one is unique, for Monet was not applying rules or ingrained habits, but was emphasizing qualities that already existed in the motif.

For all intents and purposes, it might be said that the date of *Poppy Field near Giverny* ushers in the period of avowed "colorists"—scientific and symbolistic. It was to be the role of Gauguin, beginning with his Brittany landscapes, to carry forward the interpretation of nature as flat area, decorative pattern, and symbol; and that of Neo-Impressionism to advance theories of complements, divisionism, and design.

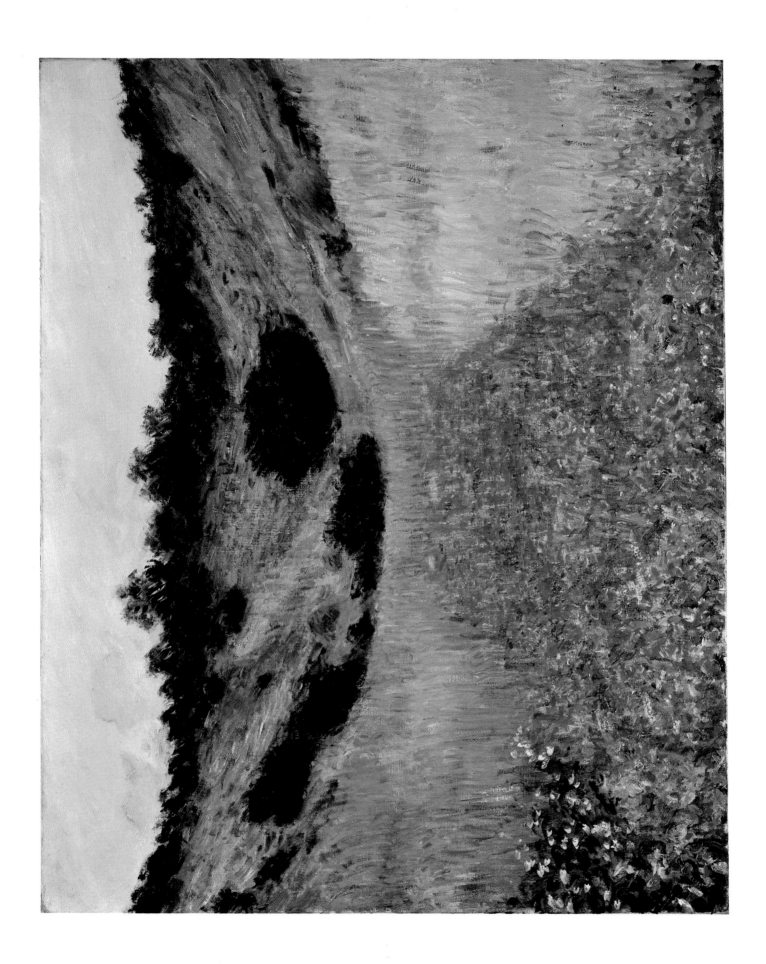

Painted in 1885

BOATS IN WINTER QUARTERS, ETRETAT

Oil on canvas, 25¾ × 32"

The Art Institute of Chicago

(Charles H. and Mary F. S. Worcester Collection)

Boats in Winter Quarters was painted at Etretat during the winter of 1885. Spatially, it is more volumetric than other coastal scenes of the eighties—boxed in by the *caloge* at the left and the receding wall at the right, deepened by the foreshortened thatched roofs at the center, and closed at the rear by the four fishing boats. Their distinctive markings of green and ocher, impeccably related to deep color tones, form a rich frieze. Such cubic space looks backward to the Gare Saint-Lazare series, or to the *Terrace at the Seaside*; but how different is the use of pigment! In place of the films of light and shadow that defined the station interior, or the spotted complementaries of the Sainte-Adresse flower gardens, here the sand, litter, and masonry are interpreted in a lava-like impasto that is almost muddy. Objects and beach merge in thick brown-violet and a variety of tans, blues, and pinks. Dense and painterly, the effect suggests passages by Utrillo, Soutine, and Ko-koschka. The combination of the controlled surface design, the dark patterns of the *caloges*, and the knowing juxtaposition of color areas results in a massive decorativeness rare in Monet's art.

This canvas again indicates the importance of Monet's art for that of Van Gogh, whose arrival in Paris in 1886 corresponded with the climax of this new intensity, which had begun after 1880. There can be little doubt that Van Gogh saw Monet's works in the Exposition Internationale at the Galerie Petit. During 1888, when Theo van Gogh was acting as Monet's agent, Vincent's letters were full of references to Monet's art. It is probably *Boats in Winter Quarters* to which he refers in a letter that includes a sketch of his own canvas, *The Tarascon Coach*: "The carriages are painted like a Monticelli, in *pâte*. You used to have a very fine Claude Monet showing four colored boats on a beach. Well, here they are carriages, but the composition is in the same manner."

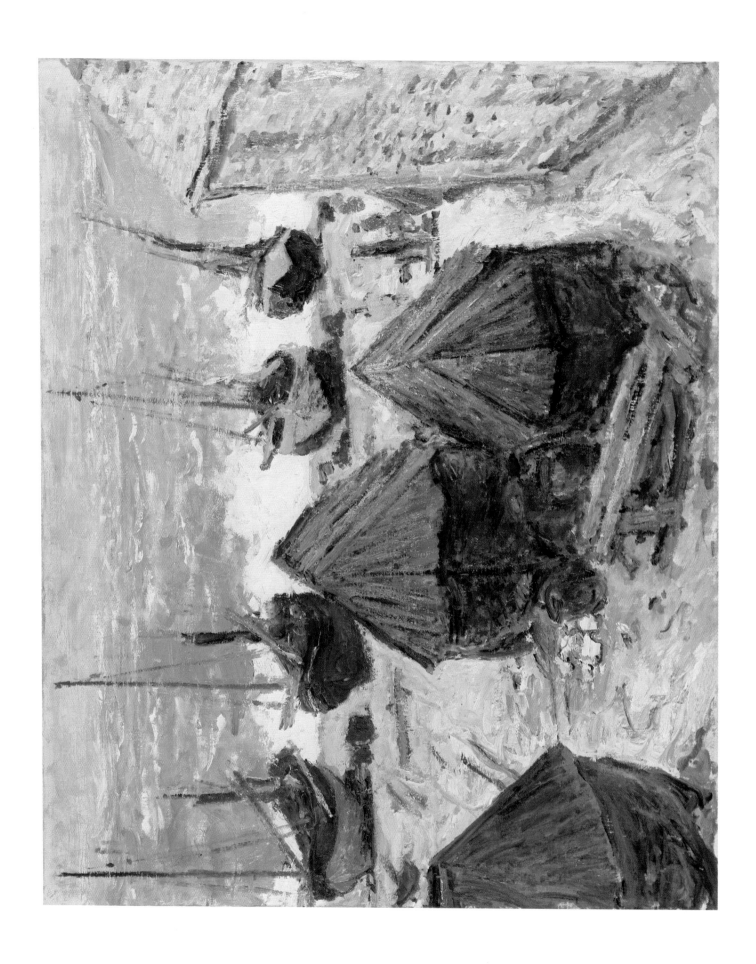

Painted in 1886

LADY WITH A PARASOL

Oil on canvas, 51⅝ × 35⅝"

The Louvre, Paris

Figure painting assumed a special importance during three periods of Monet's career: the years between 1865 and 1868 (which included the *Picnic* and *Women in the Garden*); the years at Argenteuil; and the years between 1885 and 1888, when, with his way of life firmly established at Giverny and the Hoschedé family to pose, he painted his last figure compositions. Apart from the members of his immediate family, a lifetime list of Monet's models would include only a very few friends and acquaintances. Once, about 1888, he decided to follow Renoir's advice and engaged a Paris model to pose at Giverny so he could study the figure more carefully. These plans were instantly changed, however, when Mme. Hoschedé announced that if the model entered the house, she would leave it. Thus (with the exception of *La Japonaise*) Monet's figure studies are virtually unposed, moments taken from his actual life.

The first "Lady with a Parasol" (*On the Cliff,* figure 29) is one of the most spontaneous among the previous outdoor portraits. As if surprised during a promenade, the figure, who may be Camille, turns quickly. Farther away, behind the waving grasses, a beady-eyed youngster gazes toward a spectator. Dramatically but ambiguously, mother and son (for such they appear to be) are seen from below, sharply etched against the sky.

Berthe Morisot, close to Monet at this time, observed that in his pictures "I always know toward which side I should turn my parasol." Though her intention was simply to note the precision of Monet's light effects, she unintentionally also indicates the importance of the parasol for every period of Monet's figure painting, and its effective use in this instance. The light falls from the right, subtly delineating the line of the leg; the clouds also move from right to left; and the parasol, figure, and rapidly sketched veil point out the lateral wind and sun direction like a weather vane. The pigment and the luminous shadows are as weightless as the feather-light strokes of the drawing mentioned above, and, in keeping with this keynote of sun, breeze, and movement, the horizontal field has been transformed into a vertical complex of grass rhythms. Monet's theme is the enchantment of a balmy summer day: how many times has it been so effectively elicited?

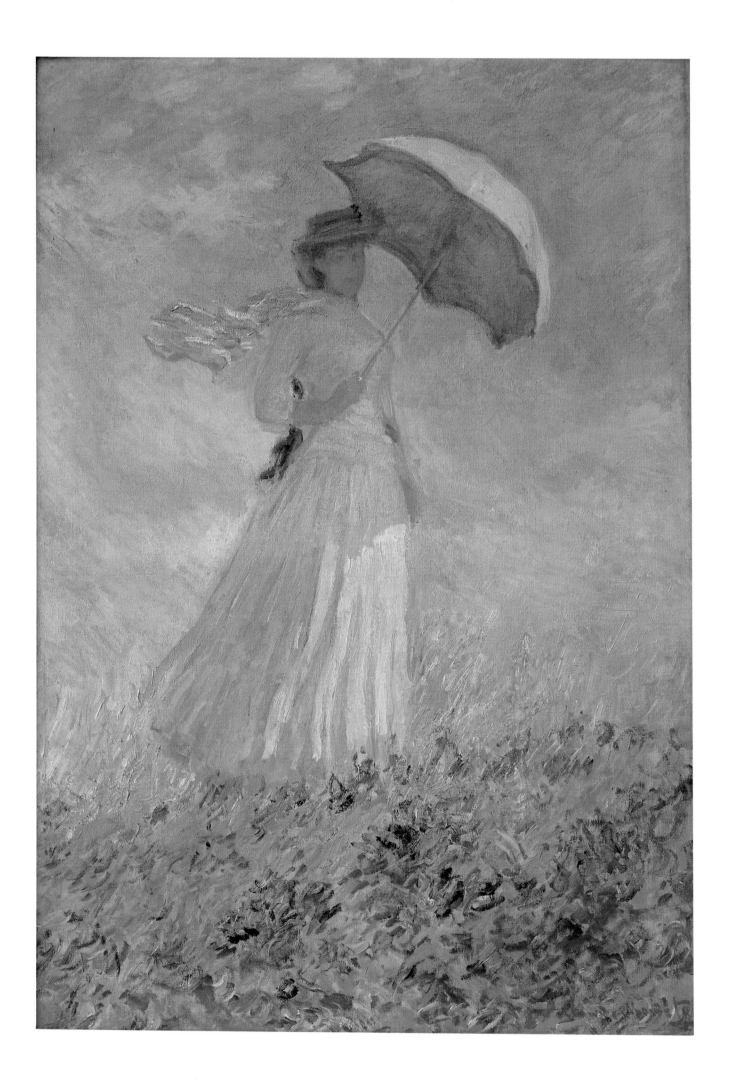

Painted in 1886

ROCKS AT BELLE-ILE

(THE NEEDLES OF PORT-COTON)

Oil on canvas, 25⅝ × 31½"

Pushkin Museum, Moscow

In October 1886, Gustave Geffroy (Monet's future biographer and the art critic of Clemenceau's newspaper, *La Justice*) began a working vacation at the tiny hamlet of Kervilhaouen, near the Côte Sauvage of the primitive island of Belle-Ile-en-Mer which lies in the Atlantic Ocean several miles off the isolated Breton peninsula of Quiberon. After sitting down to dine at the inn, Geffroy discovered that he had inadvertently occupied the reserved table of a painter who was rooming across the road. "Soon the painter made his entry," Geffroy wrote to a friend on October 3rd, "a rough man, tanned, bearded, wearing heavy boots, dressed in coarse material, a sailor's beret on his head, a wooden pipe projecting from his thick beard, and in the center of all that, a fine profile and an intelligent eye." Geffroy had already written tributes to Monet, whom he considered the "true painter, the only painter of the sea," and the two men had even corresponded. It was therefore an explosively warm encounter, and over a meal that began with soup and included wine, Breton cider, and (as a change from lobster) two meat courses, the painter and the critic initiated what was to be a lifelong friendship.

The Needles of Port-Coton are among the most awe-inspiring of Belle-Ile's fantastic rock formations. The open sea, boiling and foaming around them even in fine weather, has ground deep into the soft filling of the mica-schist surfaces and left them barbed with frightening spikes. As a climax to the dramatic themes of Etretat and Menton, it was just such a symbolically textured motif that Monet sought. In transferring the scene to canvas he conformed closely to the relative positions of the dark patterns against the churning sea, and their opposition to the stark horizon, but increased the chromatic variety of the blue, green, and violet water and its reflections on the violet rocks, attenuated the eroded forms of the "needles," and dramatized their flamelike movement in harmony with the rhythm of the waves.

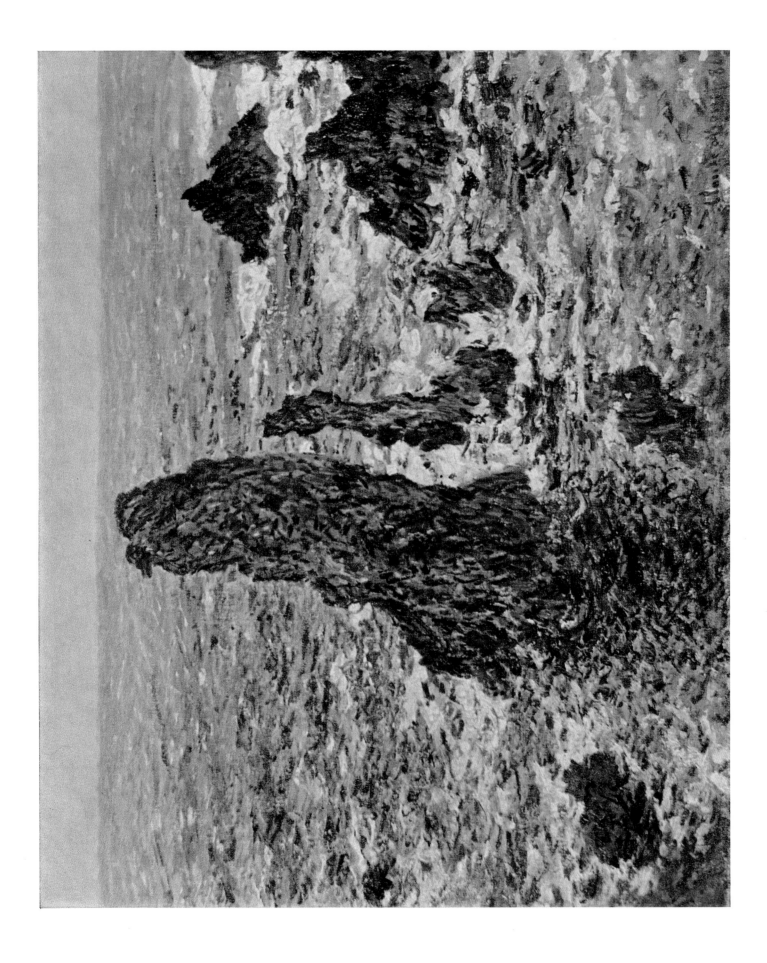

Painted about 1887

BOATING ON THE RIVER EPTE

Oil on canvas, 52½ × 57"

Museu de Arte de São Paulo

In 1924 René Gimpel, who had paid several visits to Giverny, purchased two boating studies from Monet. One, the *Pink Boat*, depicted Blanche and Suzanne Hoschedé, two of the painter's four stepdaughters. *Boating on the River Epte* is almost identical to it in subject and mood, a relaxation from the tension that had come to a peak at Belle-Ile in 1886. "What a book to write!" Gimpel comments on his purchase. "The beautiful Sundays in nineteenth-century French painting!" He is touched with poetic melancholy as the pink-gowned figures recall mixed emotions felt in adolescence when, walking alone on a summer day, "we always saw what we lacked on the other bank, inaccessible and lovely. . . . They pass quickly, these two women . . . like a dream or like a desire that cannot be gratified. . . ." Utterly French, both painting and response share the ephemeral Romanticism of Proust's *Remembrance of Things Past*, Stéphane Mallarmé's *White Water Lily* (1885), Debussy's *En Bateau* (1889), and the feminine Impressionism of Berthe Morisot.

Like the stroller envisioned by Gimpel, Monet views the couple from the shore, looking downward toward an arrangement that, though brilliantly original, finds analogies not only in earlier Impressionism but in certain of the fans affixed to the background of *La Japonaise* (page 79). The impending disappearance of the canoe toward the right is delayed by the diagonal of the upraised oar, and by the pose and glance of the rower. It is an effect that blends movement with poise, for the sharp stern also slows the boat's movement, and it is held within the picture by implied geometric traces as delicate as the threads of a spider. They relate the lines of the hull, the long oar, and the confronted figures with the foliage on the shore in a fragile network of angles and parallels.

Though the atmospheric effect is entirely unified, the composition is clarified by a striking opposition of pink and rose to complementary touches of bright turquoise and green in the foliage, and by the deep blue-violet water, which, lacking a reflected image, seems almost black. Monet later wrote to Geffroy that he was returning to "things impossible to do: water with grass that undulates below the surface." He was referring, one suspects, to the waving appearance interpreted in *Boating on the River Epte* by long threads of pink, green, and lilac.

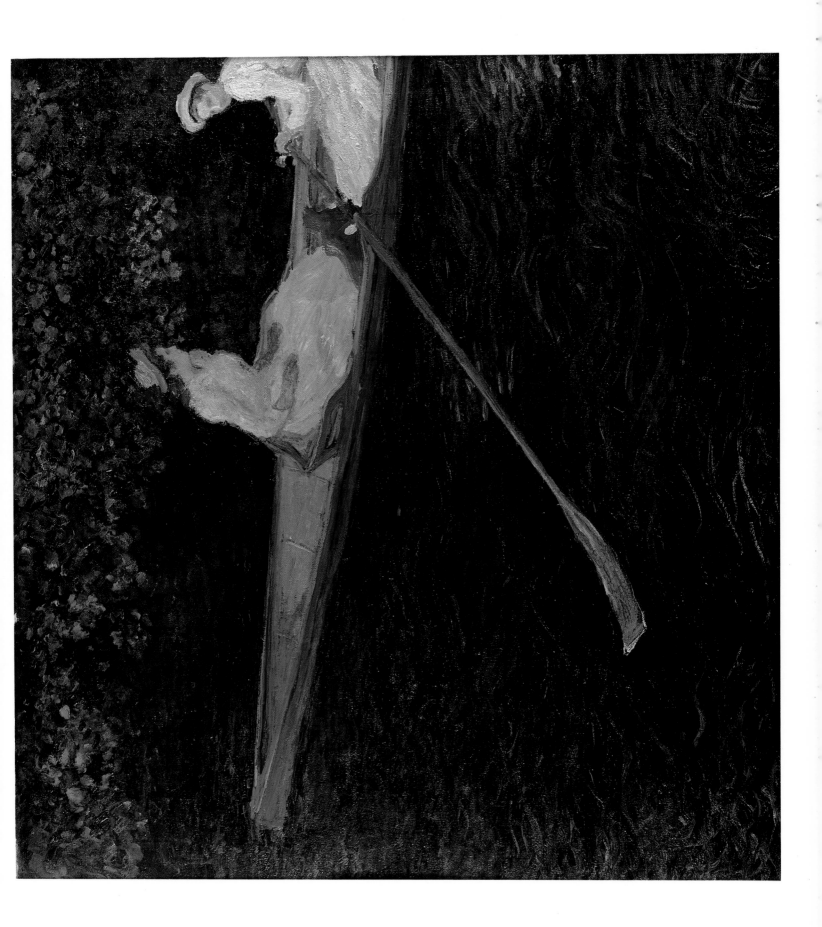

Painted in 1888

THE OLD FORT AT ANTIBES

Oil on canvas, 26 × 32"

Courtesy of the Museum of Fine Arts, Boston

(Gift of Samuel Dacre Bush)

Two divergent tendencies that influence both the choice of motifs and their treatment can be discerned in Monet's personality: one rough and daring, the other subtle, elegant, and sometimes almost feminine. The Mediterranean canvases of 1884, bold in hue, heavily pigmented, and extravagant in rhythm, reflect the former tendency; but those painted at Antibes and Juan-les-Pins during the early spring of 1888 incline toward the latter. As a letter written to Berthe Morisot from the Château de la Pinède near Antibes shows, Monet himself was sensitive to this ambivalence: "I am working terribly hard . . . but I dare not say yet that I am satisfied, because a new period of bad days jeopardizes everything I have undertaken, and besides, it is so difficult, so tender, and so delicate, and . . . [I] am so given to brutality."

In the *Old Fort at Antibes* Monet has approached the high key of the blond spring sunlight by mixing more white with his colors than previously, and by lightening his shadows; nevertheless he has not diluted the Mediterranean's unforgettable brilliance. As in the Venetian canvases dated 1908 (figures 54, 55 and page 125), the water is seen, without recession, as a trembling curtain. Over a thin, blue-green underpainting, curved or horizontal dashes of green, turquoise, cobalt, and lavender translate both wave-movement and light. Save for a few scant clouds, the sky—grading from blue to a whitened yellow-green above the horizon—is empty, so that the complex of buildings and rocks, shining with tints of pink, flesh, and cream, dominates the composition. The horizontal shore lines are severely geometric. The diagonal edges of roofs and shadows are lateral; echoed in the snow-capped mountains and the clouds, they build up toward the center from either side. It is a solution that recalls Corot's early structuralism and Cézanne's great studies of Gardanne and the Gulf of Marseilles.

The Antibes and Juan-les-Pins seascapes were shown at the Boussod and Valadon gallery, of which Theo van Gogh was director, in July 1888. They were reviewed by Félix Fénéon, to whom the series was anything but delicate: "Served by an excessive bravura of execution, a fecundity of improvisation, and a brilliant vulgarity, his renown grows; but his talent does not seem to have gained since the Etretat series." More attuned to Monet's Antibes manner, the poet Mallarmé commented admiringly, "This is your finest hour."

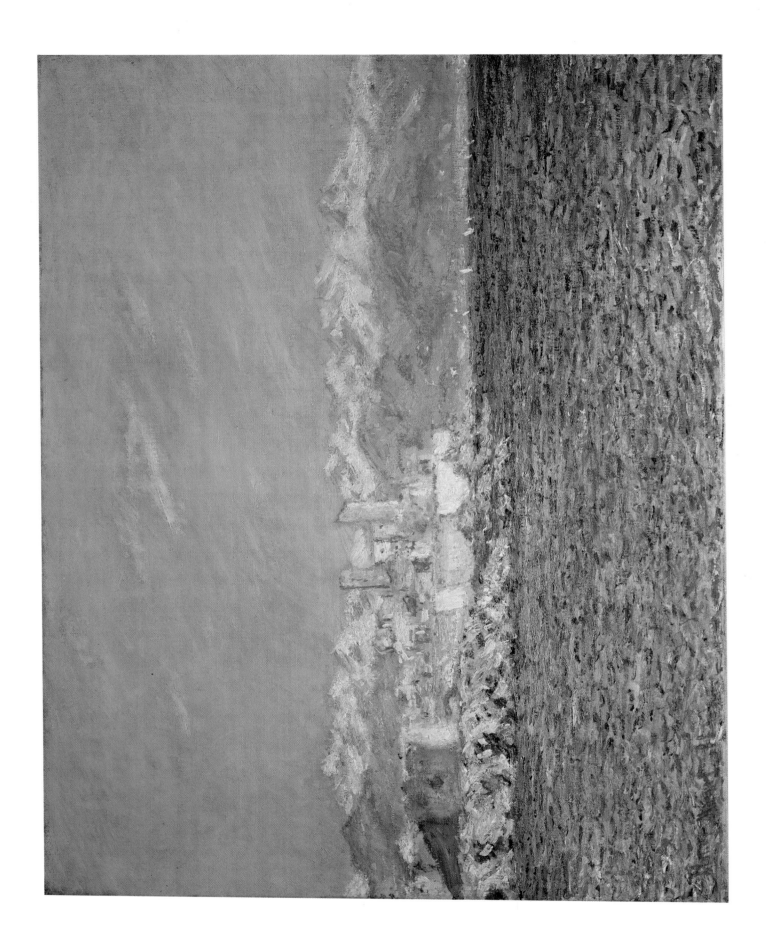

Painted in 1889

THE ROCK

(LE BLOC, CREUSE)

Oil on canvas, 28⅜ × 35¾"

Collection H. M. Queen Elizabeth, The Queen Mother

This monumental rock portrait was painted near the confluence of the two rivers
of the Creuse, at the south of the ancient province of Berry, a sparsely populated
region of western France between Orléans and Limoges. It is known for its un-
touched landscape, and for a school of "Berrichon" writers, of whom the best
known, George Sand, introduced its farms and forests into her rustic novels. It
was also the retreat of her younger friend, Maurice Rollinat, a nature poet and mu-
sician now little known outside his native province. In June 1888, from the isolated
hamlet of Fresselines, the poet wrote to Gustave Geffroy, begging him to bring
Monet, whom he was eager to meet, for a visit "as soon as possible." It is usually
said that Monet did not arrive until the following January. Accompanied by
Geffroy and other friends, he made two visits before spring, painting during the
day, sleeping at the inn, and talking and smoking before the poet's fire in the
evenings.

A major exhibition of Rodin's sculpture and Monet's paintings was held in
June 1889 at the Galerie Georges Petit. Certain of the Creuse motifs included in
this exhibition exist in several almost identical versions—among them, two pano-
ramic views of the Creuse in a new somber range of blue, brown, and violet; the
Pont de Vervit (one version strangely dated 1888); and a tiny village, La
Rocheblonde, that clings to the side of the ravine. Besides these, he painted a bare
tree (whose branches had to be removed when buds began to sprout), an un-
precedented study of a torrent rushing by the shore, and the *Rock*, which was
for years in the collection of Georges Clemenceau. Once again Monet pioneers
compositionally. Corot, Courbet, and Daubigny had represented rock formations
with magnificent fidelity and massiveness, and Cézanne had examined stone sur-
faces at close range, but no one had brought a great rock-face to such telescopic
proximity. If it were not for a certain openness of handling and the sinuous line
of the rock's upper contour, Monet would seem to have lost entirely his optical
predisposition. He models the massive stoniness of the jutting cliff in a painterly
chiaroscuro that ranges from the orange tones of earth in sunlight and the silver
of the lighted rock to deep brown-violet. In its emphasis on ponderousness,
the *Rock* is exceptional among his paintings.

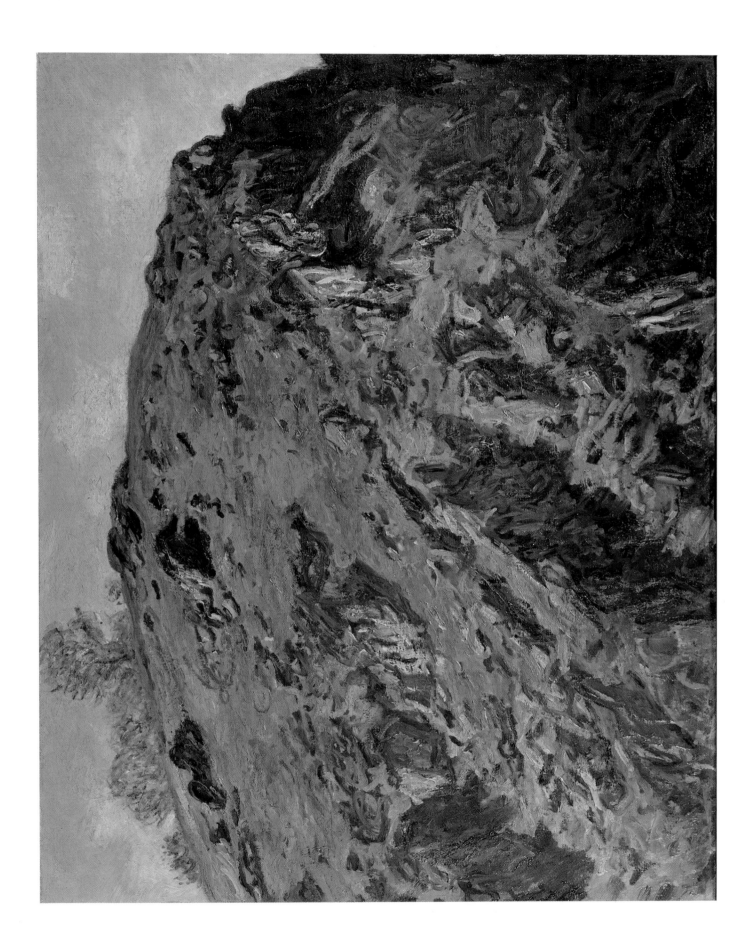

Painted in 1891

HAYSTACK AT SUNSET NEAR GIVERNY

Oil on canvas, 29½ × 37"

Courtesy of the Museum of Fine Arts, Boston

(Juliana Cheney Edwards Collection)

Walking one day on the slopes above his house with his stepdaughter, Monet is said to have been attracted by a haystack that glowed almost white, a luminous spot, in the bright sun; but by the time he returned with materials and began to paint, the effect had already changed. "When I began, I was like the others; I believed that two canvases, one for gray and one for sunny weather, would be enough," he explained many years later. Seeing the light change, he dispatched Mlle. Hoschedé to bring a fresh canvas from the house, and soon after she returned he demanded still another; and so he continued the series, working on each version only when the particular effect returned, "so as to get a true impression of a certain aspect of nature and not a composite picture." In letters to Geffroy during the summer of 1890 he speaks of painting as a "continual torture. . . . It is enough to drive one raving mad, to render the weather, the atmosphere, the ambiance." In October he complains that "the sun sets so fast I can't follow it," exasperated because he painted too slowly to achieve "instantaneity," namely, the "envelope" of colored light that momentarily unifies an entire scene. But in spite of discouragement, failure, and rheumatism, Monet painted the stacks in sunny and gray weather, in fog, and covered with snow.

Though it is one of the simplest versions, *Haystack at Sunset near Giverny* magnificently exemplifies Monet's struggle to capture the transient splendor of light. The hill, trees, houses, and fields, as passive in local color as the piled hay, are bathed in unnamable nuances of color that radiate from behind the stack. The contour of its peak, dissolved in a heated aura, writhes as if it were about to melt, and rises in an impasto as rich as that of a late Rembrandt.

Fifteen Haystacks were included in Monet's exhibition at Durand-Ruel's in 1891. All were sold within three days at prices ranging between 3,000 and 4,000 francs. Critics close to Monet, such as Geffroy, felt that he had brought the mysterious power of the universe to bear, as it were, on a point—that he was a "pantheist poet." Four years later Wassily Kandinsky was to react just as strongly to one of the Haystacks in a Moscow exhibition. To him it seemed abstract, without subject. It opened up to him, he was later to write, the "unsuspected power, previously hidden from me, of the palette, which surpassed all my dreams."

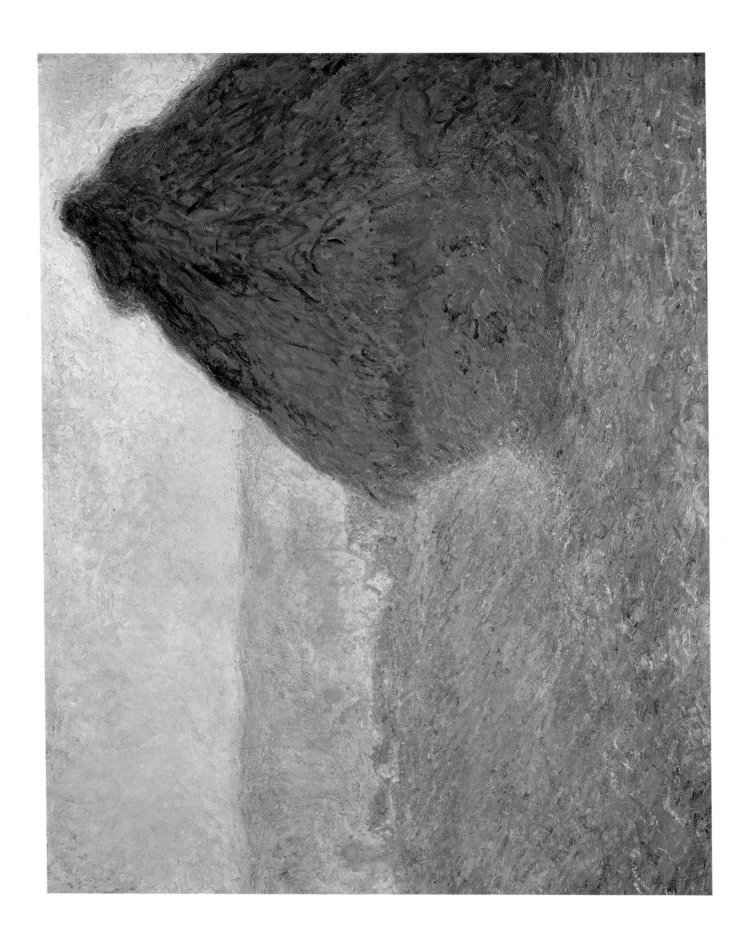

Painted in 1891

THE FOUR POPLARS

Oil on canvas, 32¼ × 32⅛"

The Metropolitan Museum of Art, New York

(Bequest of Mrs. H. O. Havemeyer, 1929.

The H. O. Havemeyer Collection)

During a walk in the neighborhood of Giverny, Monet was attracted by a magnif-icent stand of poplars growing in ordered sequence along the winding Epte River, near Limetz. After he had begun to paint them, he learned that they were about to be cut and sold at auction. He appealed, fruitlessly, to the mayor for a postponement of the sale. The problem was finally solved, somewhat extrav-agantly but with characteristic originality: Monet sought out the most probable buyer, and agreed to reimburse any amount he payed over the figure he had planned to bid, on condition that he keep bidding, and that the trees be left stand-ing until the series of paintings was completed.

The *Four Poplars* separates itself from the more than twenty other works of the series. The painting in the Tate Gallery (figure 47) is a direct sketch, and some-thing of its spirit is retained in a more finished version (figure 48). Monet worked from the same trees for the present canvas, but by his radical cropping of the composition, what was a pastoral has become a study in rectangles. Attention is concentrated on the lower sections of four tree trunks and their reflections, which divide the surface of the canvas into five vertical bands, and a horizontal strip that includes the bank and its reflection as a single area. The zigzag perspective of the distant trees is dissolved in opalescent light. With his pictorial elements dramati-cally reduced in number, Monet has given hypersensitive concern to their placing within the square frame, involving himself in an experience of horizontality and verticality in nature similar to that which, twenty years later, was to lead Piet Mondrian toward an abstract and spaceless art. The verticals of the trunks, how-ever, remain organic; forecasting the *Art Nouveau* landscapes of Gustav Klimt, they hover between the swaying lines of growth and the rigidity of geometry, as if Monet had sought to fuse the sharp opposition of curves to straight lines that had occupied him during the eighties.

The purity and iridescence of color is quite as worthy of attention as the design. The multiplicity of little touches (including both adjacent and complementary hues) is distinguishable only when one stands close to the painted surface; they quickly blend, like a mosaic of tiny beads, as distance from the picture increases, to form atmospheric tones of amazing subtlety, variety, and force. Less theoreti-cally, Monet has employed principles of design and color not unlike those of Seurat, whose final canvases were painted during the same year as the *Four Poplars.*

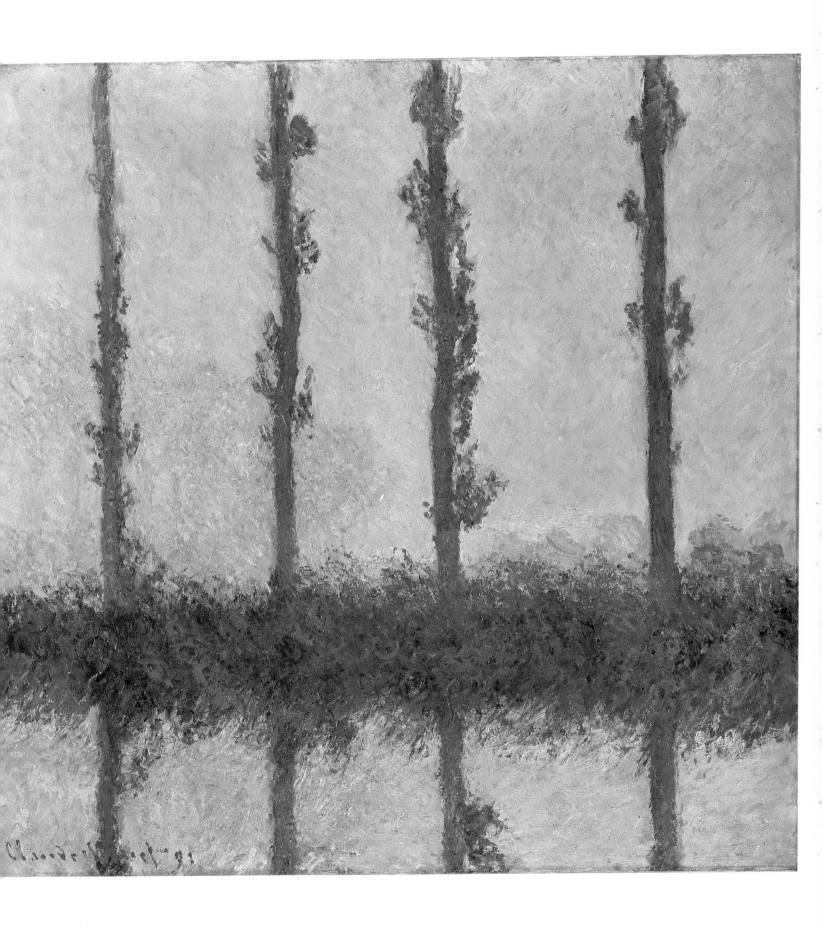

Painted in 1894

ROUEN CATHEDRAL: THE FAÇADE AT SUNSET

Oil on canvas, 39½ × 25¾"

Courtesy of the Museum of Fine Arts, Boston

(Juliana Cheney Edwards Collection)

Monet's renowned series of the Cathedral at Rouen seen under different light effects was begun from a second-floor window above M. Edouard Mauquit's shop, Au Caprice, at 81 Rue du Grand Pont, opposite the façade, during the winter months of 1892 and 1893, and were completed at Giverny. His exhibition of 1895, held at the Durand-Ruel Gallery, included twenty Cathedrals among a total of fifty works, but the eighteen frontal views were singled out for both exaggerated praise and attack. Changing canvases with the light, Monet had followed the hours of the day from early morning, with the façade in misty blue shadow, to the afternoon, when it is flooded with sun, and finally to the end of day, when the sunset, disappearing behind the buildings of the city, weaves the weathered stonework into a strange fabric of burnt orange and blue. "The Revolution of the Cathedrals" was the title given by Clemenceau to his eulogistic article in *La Justice*, He separates the works into four groups: gray, white, iridescent, and blue. "The painter has given us the feeling," he writes, "that he could have . . . made fifty, one hundred, one thousand, as many as the seconds in his life. . . ."

It is to be expected that an art concentrating many innovations will be controversial. Monet poetically demonstrated, as motion and color photography were to prove, that nature's color lies in atmosphere and constantly changing light rather than inert materials; that during a short time the appearance of a single substance can modulate through the entire spectral and tonal range. The lack of precedent for other pictorial qualities can be seen in a criticism of Georges Lecomte's, cited in the journal of Paul Signac: "Not enough sky around, not enough ground. . . ." Signac himself added that he fully understood what the Cathedrals were: "marvelously executed walls." The Irish novelist George Moore objected to the "feat" of painting "twelve views of the cathedral without once having recourse to the illusion of distance." He also bridled at the new fusion of subject and art object, for he added that the paint surface was "that of stone and mortar," suggesting that Monet must have "striven by thickness of paint and roughness of handling to reproduce the very material quality of the stonework."

Though rough in actuality, this version is less stonelike in appearance than certain others, for the oscillation of warm and cool brush strokes transforms the masonry into an oddly sulphurous and ephemeral screen. Yet surveying the group as a whole, one is struck by the close approach made by Monet's art of transient effects—in the Cathedrals, ordered by their enduring Gothic skeleton—to the flat, pulsating "façades" painted by Braque and Picasso more than fifteen years later.

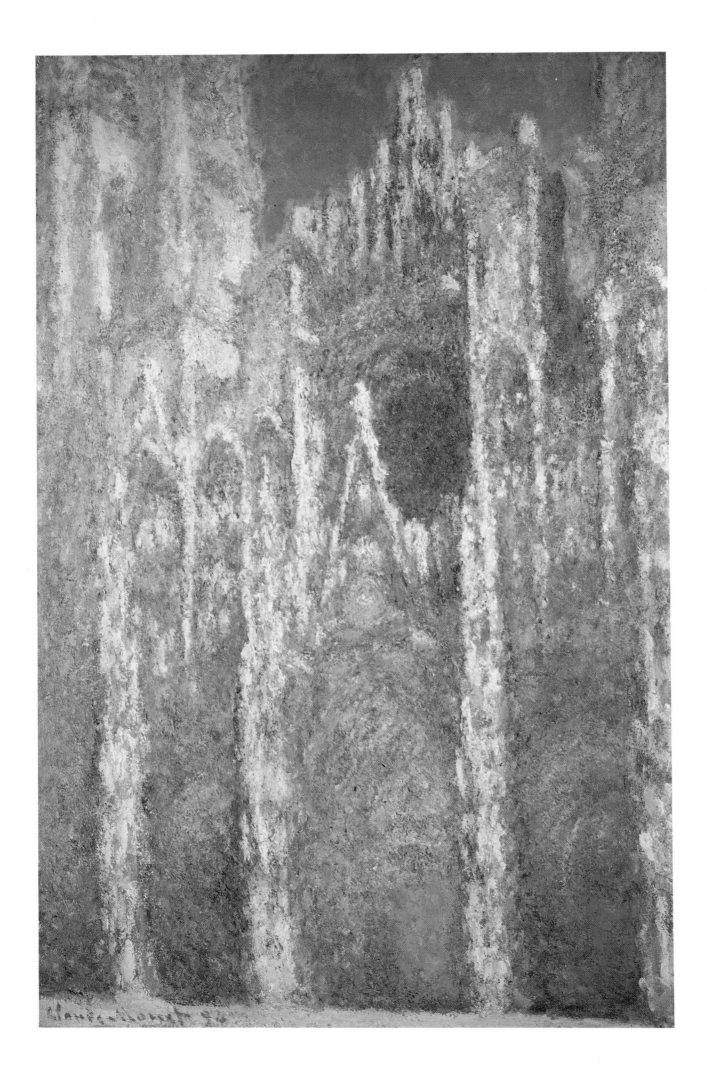

Painted in 1897

BRANCH OF THE SEINE NEAR GIVERNY

Oil on canvas, 34¼ × 38½"

Courtesy of the Museum of Fine Arts, Boston

(Gift of Mrs. Walter Scott Fitz)

Monet's style, like that of most innovating artists, evolved as he grew older, and with a discernible internal logic; but for several reasons its phases are especially hard to follow. Because he submitted more completely than any other Impressionist to the caprices of nature, no tendency became so ingrained that its direction could not be altered by the next motif. By the same token, he was continually led to undertake untried subjects, and he had both the skill and the physical stamina to carry them out. The disconcerting variety of his art, therefore, reflects that of the natural world.

Because there was no snow at Giverny, he returned, during the winter months of 1896 and 1897, to paint Varengeville, Pourville, and Dieppe once more: "It is a joy for me to see the movement of the sea again," he writes to Geffroy. Summers, he worked on a new series of Mornings on the Seine, eighteen of which were shown in 1898. Fifty-six years old, he nevertheless rose before dawn to await the moment when the sky was pink and the little tributary of the Seine was covered with morning mist. Typical of this group, *Branch of the Seine near Giverny* marks a change in his development. Local colors have been entirely supplanted by a single atmospheric tone—the cool blue of early morning. The broken brush stroke of Impressionism has also been abandoned, and he has again employed the almost square shape of *Boating on the River Epte*. It is a shape not common in the history of painting, and because of its equivalence, it is imbued with an intrinsic motion-lessness. To all intents and purposes, Monet abandoned figure painting after 1890 to concentrate more undividedly on nature and on his recurrent themes of light, water, and reflections. Here, for the first time, the reflected image is assigned a pictorial function and a solidity all but equal to its origin. Mass and weight, which Monet's vision had always minimized, have now lost meaning completely. The composition is barely altered by inversion, and if the painting is held on its side, reality and illusion unite in an abstract symmetry. Except for the slightest swell, no movement disturbs the silence; the mood is mysterious and meditative—an introduction to the mood of the water landscapes which will occupy his last years.

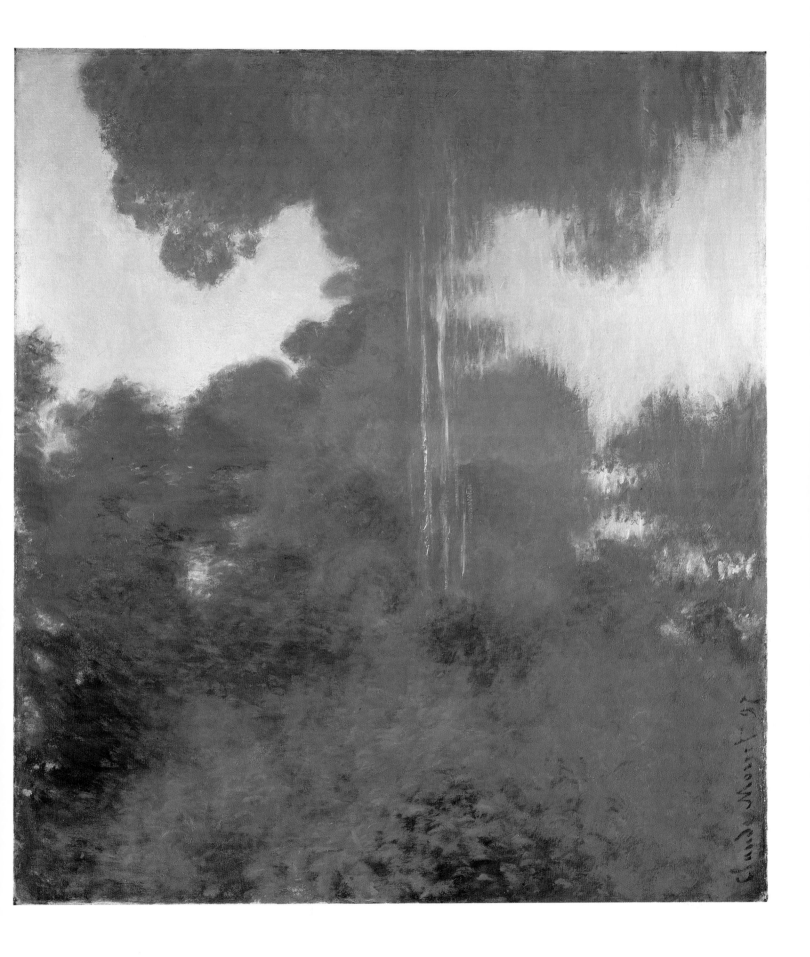

Painted in 1903

THE HOUSES OF PARLIAMENT

Oil on canvas, 32 × 36¼"

National Gallery of Art, Washington, D.C.

(Chester Dale Collection)

This mysterious view of the Thames in winter was begun (though not completed) from a window or balcony of Saint Thomas's Hospital overlooking the river. Like the *Impression*, it captures an actual atmosperic effect, but one which appears unreal and visionary. Its theme is not the stone architecture, but the silhouette and reflections, and colored light suspended in moisture-laden air. Monet seldom substantially altered a subject, but the Thames views (see also figures 51, 52 and page 65), more than any others, brought out his latent Romanticism. He has heightened the eerie mood not only by extreme simplification and the addition of the boatman, but also by noticeably narrowing and heightening the Gothic towers and spires. In wisps, the touches that constitute the air seem to follow the fog's drift. Volume and depth are created (as in the late landscapes of Cézanne) only by the many-toned touches of pigment, which give the atmosphere as tangible an existence as that of the solid objects.

Monet recalled his attitude toward the Thames motifs in conversations of 1919 and 1920: "I love London so much, but . . . only in winter. . . . It is a mass, an ensemble, and it is so simple. But above all in London I love the fog. . . . It is the fog that gives it its magnificent amplitude; its regular and massive blocks become grandiose in that mysterious mantle. . . . How could the English painters of the nineteenth century have painted the houses brick by brick? Those people painted bricks that they did not see, that they could not see!" While he was painting from his rooms and balcony at the Savoy Hotel on the Embankment, or from the Hospital, he was sometimes surrounded by as many as ninety canvases on which he was working. When the light suddenly changed he was forced to shuffle through them "feverishly" in search of the version that most resembled the new effect. Following the third and final winter on the Thames, the unfinished studies were carried forward at Giverny. "I cannot send you a single canvas of London," Monet wrote to Durand-Ruel in 1903, "because . . . it is indispensable to have them all before me, and to tell the truth not one is definitely finished. I develop them all together. . . ." Thirty-seven were exhibited in May 1904; in the catalogue, Octave Mirbeau's flamboyant pen wrote of "the multiple drama, infinitely changing and shaded, somber or magical, anguishing, charming, florid, terrible, of the reflections on the waters of the Thames; of nightmare, of the dream, of mystery, of fire, of the furnace, of chaos, of floating gardens, of the invisible, of the unreal. . . ."

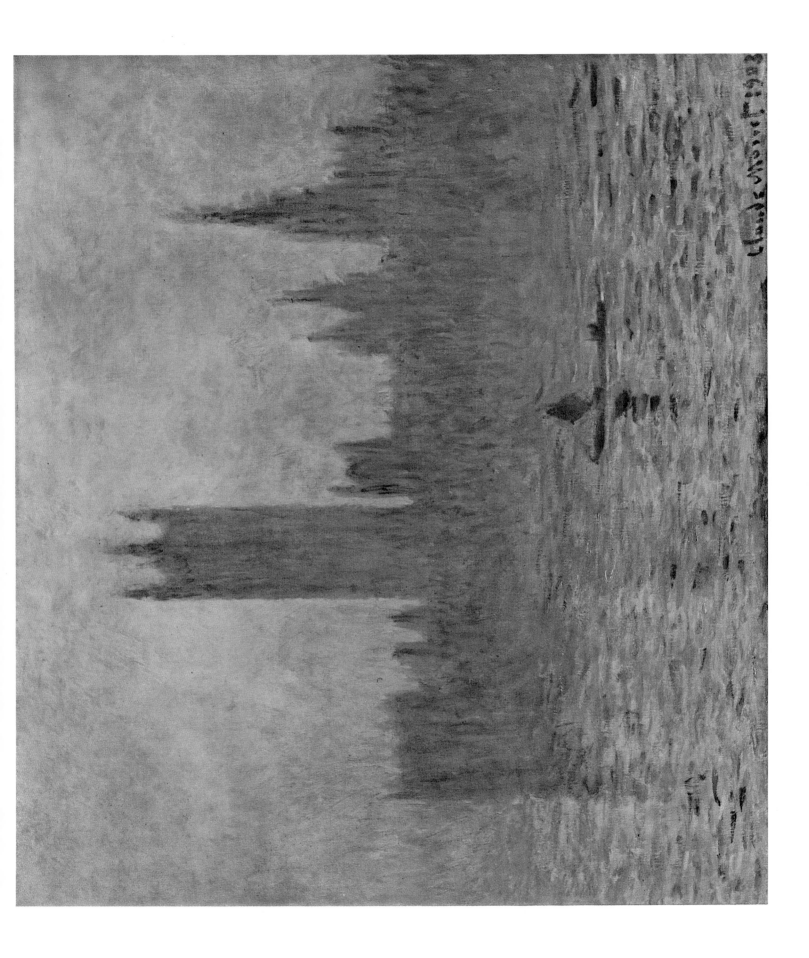

Painted in 1904

WATER GARDEN AT GIVERNY

Oil on canvas, 35½ × 36¼"

The Louvre, Paris; on loan to the Musée de Caen

In 1890 Monet bought a strip of marsh land that lay across the road from his flower garden, between the railroad line and a tributary of the little River Epte. In a project that was extended at least three times, workmen were set to installing sluices, digging a shallow pond, and diverting the water of the river through it. Weeping willows, iris, and bamboo were planted near the pool; along the fence that enclosed it, roses; and on the water, several varieties of water lilies. Monet painted the west end of the pool with the newly completed Japanese footbridge as early as 1892; but in the series of 1899-1900 (figure 56) the vantage point is closer, with the foreground shore eliminated. Like a creative photographer, Monet shifted his frame from version to version, until the shore was often entirely excluded. Each morning and afternoon he visited the water garden to watch the lily blossoms open and close; against the shimmering images in the mirror on which they lay, he found them sufficient subjects—first for meditation, then for creation.

But who before Monet would have dared to paint so insubstantial a motif? He found a composition in what would have been only a background detail for another painter. In 1889 he had painted a study of rapids on the Creuse that, like the *Water Garden at Giverny*, includes only a narrow strip of shore at the top of the design; but by 1904 the inverted world of reflections in water offered him an experience of reality according to entirely new principles of position, relationship, and space. On the pond's surface, the groups of lily pads define an invisible horizontal plane by their careful spacing, but at the same time ascend vertically, in a subtly implied triangle, toward an apex that bisects the upper margin. Almost square, the tranquil composition is complete, though it nevertheless remains a fragment of a larger whole.

In 1909, when forty-eight water landscapes were exhibited at Durand-Ruel's gallery, the critic Roger Marx "imagined" a conversation (which may not have been entirely hypothetical) in which Monet speaks thus: "I have been tempted to employ this theme of water lilies in the decoration of a salon: carried along the walls, its unity, enfolding all the panels, would have given the illusion of an endless whole, of water without horizon or bank; nerves tense from work would be relaxed there... and to him who lived there, this room would have offered the refuge of a peaceable meditation in the center of a flowering aquarium."

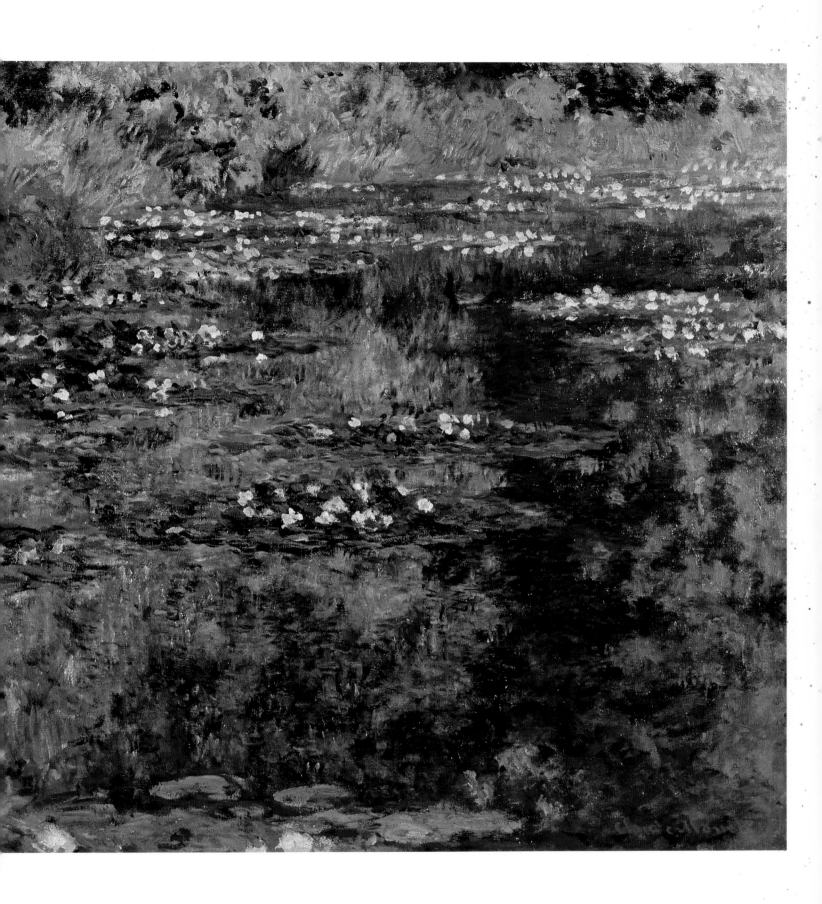

Painted in 1908(–12?)

VENICE, PALAZZO DA MULA

Oil on canvas, 24½ × 32"

National Gallery of Art, Washington, D.C.

(Chester Dale Collection)

Monet's lack of interest in the romantic myth of Venice is implicit in a remark made to Renoir when, in their youth, the two friends had stopped before a Canaletto in the Louvre: "He hasn't even put in the reflections of the boats." That he made the Venetian trip, however belatedly, was a coincidence. In 1908 he and his wife were invited by an American friend of John Singer Sargent to visit his *palazzo* on the Grand Canal. Depressed by poor health and displeased with his work, Monet accepted, with the hope of self-renewal, and was immediately captivated—but by the "unique light" rather than the splendor of the city. By October he was installed at the Grand Hotel Britannia, from the landing stage of which he began a series of views of San Giorgio (figure 55). "It is so beautiful," he wrote to Geffroy in December, "I console myself with the thought of returning next year, for I have only been able to make attempts, beginnings. But how unfortunate not to have come here when I was younger, when I was full of audacity!"

The *Palazzo da Mula* was begun from the opposite bank of the Grand Canal at the termination of the narrow Calle del Dose da Ponte. In a complete break with picturesque precedent, the palace and adjoining buildings have been shorn of their upper stories and disassociated from their setting to provide an almost abstract pretext for oscillating color and a dynamic pattern of horizontals and verticals. The façades are exactly parallel to the frame and picture plane, but at an incommensurable distance from it. Though lacking both mass and weight, their architectural divisions are strongly articulated, and the openness of the flat design is controlled by the dark pattern of the doorways and gondolas, and by subtle readjustments of detail. As a young French writer commented at the time, "It seems that the rose and blue façades float on the water." More than that, they seem almost to be suspended from above, owing to the negligible recession of the water surface and the emphasis given to vertical reflections. Monet worked on the series until 1912, so all transient colors—even those of the mosaics on the building at the right—are generalized to form a magical atmospheric blueness whose touches range between yellowish green and lilac.

Because they were finished from memory, Monet was deeply dissatisfied with the Venetian canvases. He did not realize that he was again pioneering, but in a different art of synthesis, structure, and rectilinear rhythm. Here is the culmination of the architectonic direction announced in 1871 by *Westminster Bridge.*

124

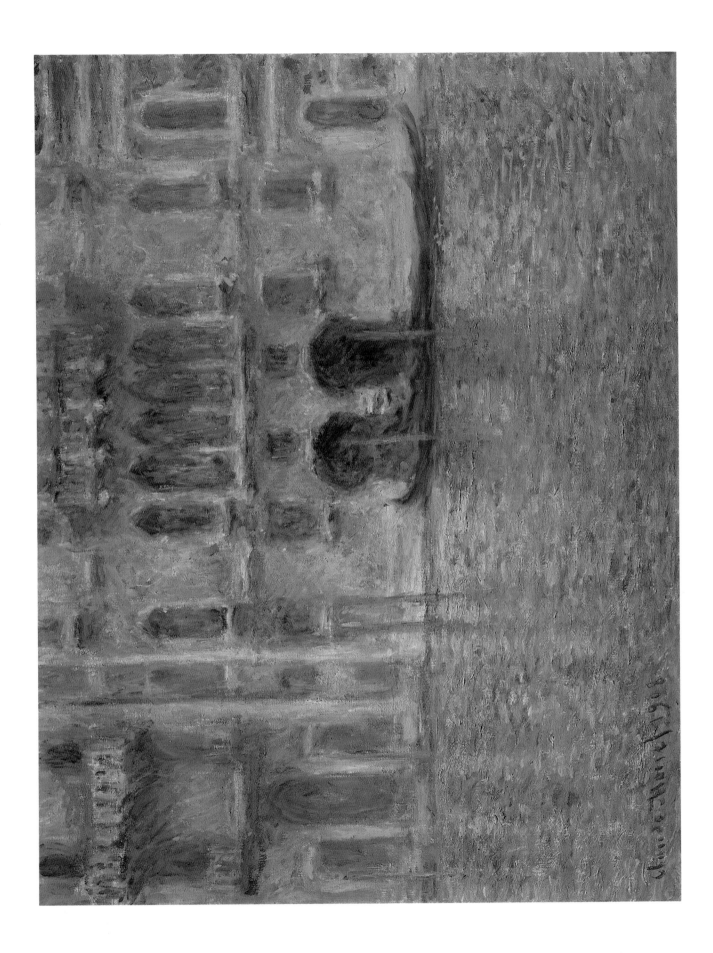

Painted about 1918

WATER LILIES

(NYMPHEAS)

Oil on canvas, 59¼ × 79"

Collection unknown

The idea of combining a group of water landscapes to form a complete and encompassing environment probably entered Monet's mind during (if not before) the exhibition of 1909 ; lonely and discouraged after the death of his second wife in 1911, he all but ceased to paint. By the time the Venetian series was finished, a cataract had already begun to form over one eye. Before the war, came the death of his son Jean, whose wife, Blanche Hoschedé, became his assistant, painting companion, and protector. It was not she, however, but Clemenceau who finally roused him from mourning and inactivity: "I had talked to him," Monet reported to the Duc de Trévise later, "of the kind of decoration I should have liked to carry out in the past. He answered: 'It is superb, your project! You can still do it.'" Monet also received a letter from a lady admirer who spoke of a "room almost round, that you would decorate and that would be encircled by a beautiful horizon of water." His enthusiasm once rekindled, he planned a huge new studio which, despite wartime shortages, was completed by 1916 and outfitted with large canvases on rolling bases.

Two years later Monet was visited by René Gimpel and Georges Bernheim. They had heard rumors of "an immense and mysterious decoration" on which Monet was working in secret. To their surprise he willingly led them through the garden to the mural studio. On entering the glass-roofed interior they found themselves "before a strange artistic spectacle: a dozen canvases placed in a circle on the floor, one beside the other, all about two meters [78³/₄"] wide and one meter twenty [47¹/₄"] high; a panorama made up of water and lilies, of light and sky. In that infinitude, water and sky have neither beginning nor end. We seem to be present at one of the first hours in the birth of the world. It is mysterious, poetic, delightfully unreal; the sensation is strange; it is a discomfort and a pleasure to see oneself surrounded by water on all sides.

"'All day long I work on these canvases,' Monet said to us. 'I am brought one after the other. In the atmosphere, a color reappeared that I had found yesterday and sketched on one of the canvases. Quickly the picture is passed to me and I endeavor as far as possible to fix that vision definitively; but usually it disappears so rapidly that it has passed to make way for another color already introduced several days ago in another study that is placed before me almost instantly—and it continues like that all day.'"

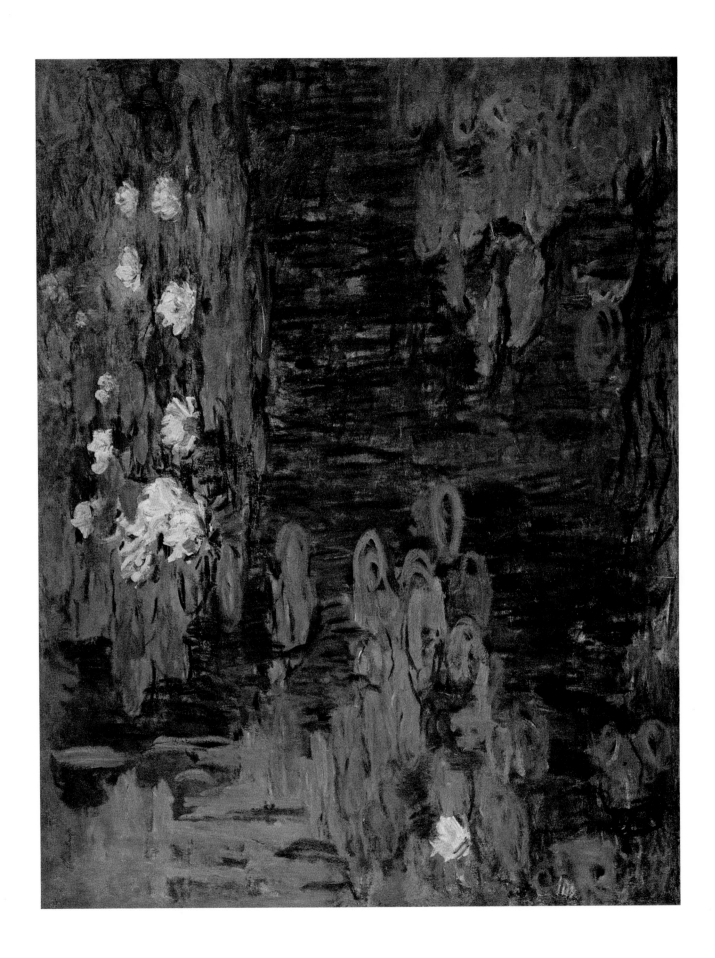